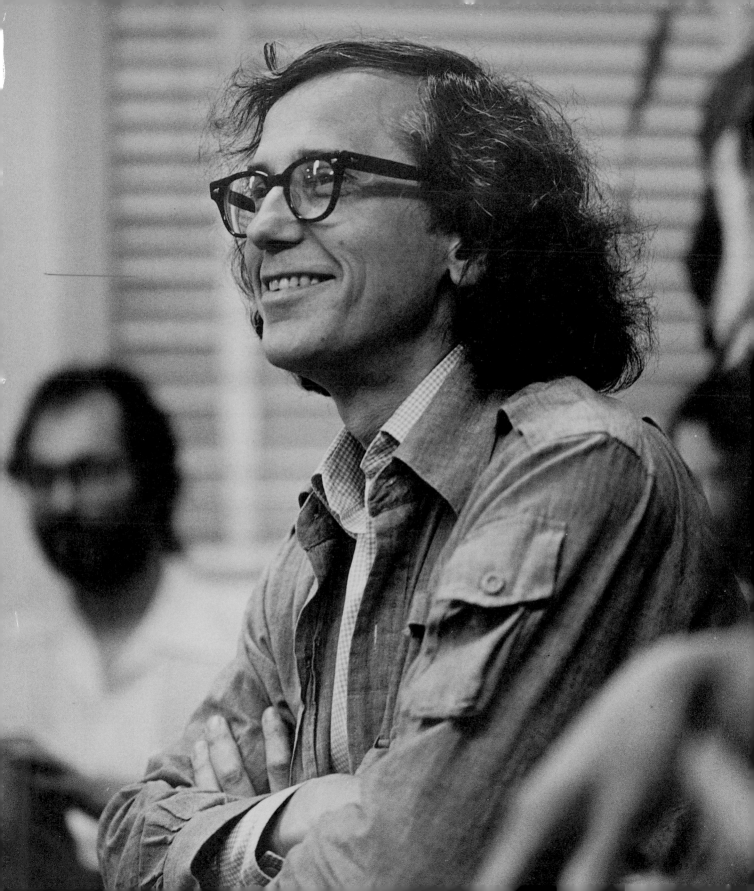

CHRISTO COMPLETE EDITIONS 1964 – 1982

Catalogue Raisonné and Introduction by Per Hovdenakk
Werkverzeichnis und einführender Text von Per Hovdenakk

New York University Press

© 1982 by
Verlag Schellmann & Klüser, Munich

Published in the United States of America
by New York University Press
Washington Square
New York, N.Y. 10003

Library of Congress Cataloging in Publication Data
Hovdenakk, Per.
Christo, complete editions, 1964–82.
1. Christo, 1935 – - - Catalogs.
I. Schellmann, Jörg. II. Title.
N7193.C5A4 1982 709'.2'4 82-6468
ISBN 0–8147–3418–9 AACR2

Introducing text and Catalogue Raisonné:
Per Hovdenakk
Editor, German Translation:
Jörg Schellmann
Printed by Weber Offset, Munich
Graphic design: Jörg Schellmann

Printed in Germany

Per Hovdenakk

Christo's Schaffen der letzten 20 Jahre ist ungewöhnlich umfangreich. Wenige andere Künstler seiner Generation haben eine so große Produktion vorzuweisen. Neben einer Vielzahl von Objekten, Zeichnungen, Collagen und Grafiken, die im Atelier entstanden, hat Christo vor allem an den großen, zeitlich begrenzten „Projekten" gearbeitet: „Wrapped Coast", „Valley Curtain", „Running Fence" und „Wrapped Walk Ways", Projekte, in die Christo seine ganze Arbeitskraft investierte und die er mit zielbewußter Hartnäckigkeit, die typisch für seine Arbeitsweise ist, verfolgte.

Als Christo 1958 aus Bulgarien über Prag und Wien nach Paris kam, machte er seine ersten Experimente mit dem Einpacken von Objekten. Die künstlerischen Probleme sind seitdem die gleichen geblieben, wenn Christo auch versucht hat, die Prinzipien der ersten Verpackungen in immer neuer Weise zu benutzen, die Komplexität des künstlerischen Ausdrucks zu entwickeln und das thematische Material zu erweitern: Vom Verhüllen einfacher Objekte hin zu komplexen Gebilden sozialer Beziehungen, wie sie bei der Realisierung der großen Projekte entstehen.

Man kann sagen, daß Christo's Arbeiten alle von einem zentralen Gedanken ausgehen: Wie kann die zunehmende Entfremdung unserer Kultur mit einer einfachen Manipulation der „Realität" überwunden werden, wie können die intellektuelle Wahrnehmung einerseits und die sinnliche andererseits zu einer totalen und umfassenden Erfahrung der Existenz vereint werden?

Ein besonderes Merkmal von Christo's Arbeiten ist dialektische Klarheit und Verständlichkeit. Das wird schon in seinen frühen Arbeiten deutlich und verstärkt und entwickelt sich im Laufe seines Schaffens immer mehr zum zentralen Thema. Man kann annehmen, daß der Wunsch nach Klarheit und Deutlichkeit auf Christo's Erziehung in Bulgarien zurückzuführen ist, die ihm eine gründliche Ausbildung in marxistischer Dialektik vermittelte und die die systematische Entwicklung sozialer und politischer Ideen zum Ziel hatte. Größe und Menge sind wichtige Elemente wirksamer Kommunikation, und es ist aus Christo's Erziehung heraus verständlich, daß diese Elemente bei all seinen öffentlichen Projekten eine wesentliche Rolle spielen. Es ist Folge des Wunsches nach Deutlichkeit und Verständlichkeit, daß Christo in seinen Zeichnungen Texte (objektive technische und topographische Worte und Zahlen) benutzt, die die visuelle Darstellung unterstützen oder erläutern.

Aus seinem Wunsch nach Verständlichkeit ist auch Christo's kooperatives Verhältnis zu Presse und Massenmedien zu verstehen. Viele andere zeitgenössische Künstler haben ein eher kritisches Verhältnis zu den Medien, die sie vor allem als Instrument sozialer und politischer Manipulation sehen. Christo's Einstellung zu den Medien ist anders: Er benutzt sie und verarbeitet sie in seinen Werken. Ein großer Teil seiner Arbeit besteht aus Projekten, die in einem bestimmten sozialen Umfeld entstehen und sich mit ihm auseinandersetzen – wie das Verpacken von öffentlichen Gebäuden und Denkmälern, „Valley Curtain" und „Running Fence". Die meisten dieser Projekte haben physische und ökonomische Ausmaße, die von selbst die Neugier und das Interesse von Publikum und Presse auf sich ziehen. Noch wichtiger ist, daß diese Projekte ein komplexes Zusammenwirken von Behörden und Menschen beim Erteilen von Genehmigungen, bei der Suche von technischen und praktischen Lösungen erfordern; die Massenmedien sind ein wichtiger Teil der während eines solchen Projektes ablaufenden Kommunikationsprozesse.

Christo's große Projekte beginnen und enden als visuelle Ideen. Er fertigt zunächst Zeichnungen, Collagen und Modelle an, an denen er die visuellen und ästhetischen Aspekte des Projekts erarbeitet. Gleichzeitig sammelt er technische Daten, testet praktische Lösungen, sucht den Ort aus, an dem das Projekt am besten realisiert werden kann und stellt die Idee den Behörden bzw. privaten Unternehmen vor, deren Hilfe für die Realisierung notwendig ist. Diese drei Vorgänge – die Vorbereitungsarbeit im Studio, das Testen technischer Möglichkeiten und die Reaktionen der Umwelt – wirken aufeinander ein und sind gleichwertige Elemente des Projektes.
Die Zeichnungen, Collagen, Modelle und Druckgraphiken, die im Atelier entstehen, dokumentieren die verschiedenen Entwicklungsstufen von der ersten Idee bis zum fertigen Projekt. Gleichzeitig sind sie selbst Elemente dieses Prozesses. Christo benutzt sie, um Erfahrungen zu sammeln und zu verarbeiten, um neue Ideen in das Projekt einzubringen, um dem Projekt mit all seinen technischen, praktischen und politischen Bedingungen allmählich seine autonome Gestalt zu geben.

Diese (Vor-)Arbeiten, einschließlich der Druckgraphik, haben die Aufgabe, die Idee der Außenwelt mitzuteilen und – das ist wichtig – Geld für die Realisierung des Projektes aufzutreiben. Das Ob und Wie der Graphikproduktion wird oft von der Arbeit an den großen Projekten bestimmt.
So entstanden z. B. viele Blätter 1968 im Zusammenhang mit dem 5600 Kubikmeter-Paket in Kassel und 1972 anläßlich des Valley Curtain Projekts. Sie mußten unter großem Zeitdruck produziert werden und sind daher technisch weniger aufwendig als die meisten anderen Farblithographien und Collagen.

Wie andere zeitgenössische Künstler gebraucht Christo die unterschiedlichsten druckgraphischen Techniken als Mittel der Verbreitung seiner künstlerischen Ideen. Wie andere Künstler benutzt er in seiner Druckgraphik die Photographie. Photos werden zu Dokumentationszwecken direkt reproduziert, werden als Collagenelemente in Zeichnungen und Graphiken eingebaut oder dienen als Ausgangsmaterial für weitere Zeichnungen und Collagen.
Die Tatsache, daß Christo in seinen Entwürfen Photos und Text verwendet, präjudiziert die Wahl der Drucktechnik für seine Graphik. So wurden die meisten Blätter in Techniken realisiert, die sich zur Reproduktion von Photos und Text eignen: Siebdruck bzw. Lithographie von Metallplatten. Es gibt nur eine einzige Radierung (mit Lithographie) in Christo's Graphikproduktion; andere klassische Drucktechniken wie Holzschnitt oder Aquatinta fehlen ganz.

Der Einsatz von Farbe, die technische Ausgestaltung einer Graphik können sehr unterschiedlich sein und werden von Christo weniger nach den Regeln formaler Ästhetik als nach den Erfordernissen und dem Charakter des betreffenden Gegenstandes entschieden.

Christo hat eine sachlich-nüchterne Einstellung zu den graphischen Techniken. Er kümmert sich wenig um konventionelle Regeln, sondern benutzt die Verfahren, in denen er seine Ideen am besten visuell umsetzen kann.

Auflagenobjekte

Christo's Auflagenobjekte sind nicht gewöhnliche „Multiples" in dem Sinne, daß sie industriell oder nach dem Modell des Künstlers von einem Handwerker hergestellt wären. Sie sind alle von Christo selbst gemacht und daher eher „Original-Objekte in Serie". Daß Christo die ganze Auflage selbst herstellt, gibt jedem einzelnen Exemplar einen individuellen Charakter. Bei einigen Serien (z. B. den verpackten Zeitschriften) war dies die Absicht des Künstlers, bei anderen entstand der individuelle Charakter durch den Verpackungsprozeß selbst.

Die Objekte beziehen sich auf die zentralen Themen in Christo's Werk. Die verpackten Bücher, Zeitschriften und Blumen z. B. haben eine direkte Verbindung zu anderen verpackten Gebrauchsgegen-ständen oder erklären sich aus Christo's Interesse an den Massenmedien. Ein Objekt kann auch Teil eines ganz bestimmten Projekts sein, wie bei den „verpackten Kartons", deren Versand und anschließendes Schicksal eine Aktion für sich darstellten.

Sehr häufig entstanden Objekte aufgrund äußerer Ereignisse (wie das Eintüten des Kölner Doms anläßlich des Intermedia-Festivals in Heidelberg) als Aktion der Geldbeschaffung für Vorhaben, an denen Christo selbst beteiligt ist (wie bei dem verpackten Buch „Modern Art") oder zur finanziellen Unterstützung von Unternehmungen, mit denen Christo sympathisiert (wie bei der verpackten Zeitschrift „Pour" und dem verpackten „Chicago Magazine").

Die Produktion von Auflagenobjekten ist weit unregelmäßiger als die von Graphiken; einige Auflagen wurden zudem nur zum Teil tatsächlich hergestellt.

The body of Christo's work during the last 20 years is particularly comprehensive. In fact, it would be difficult to find many other artists of his generation who could show such a large output. In addition to the great number of objects, drawings, collages and graphics which are the result of his work in the studio, there are the temporary large scale projects, such as, Wrapped Coast, Valley Curtain, Running Fence and Wrapped Walk Ways; each in itself representing an enormous amount of work and a systematic and purposeful obstinacy which is characteristic of Christo.

In 1958, when Christo arrived in Paris from Bulgaria via Prague and Vienna, he began to experiment with the idea of wrapping objects. The artistic problems that are involved in the wrappings have been the main elements of Christo's work ever since. With great persistence he has tried to use the principles from the first wrappings ever in new ways. The evolution and the increasing complexity of the artistic idioms has gone hand in hand with an expansion of the thematic material, from the shrouding of simple objects to dealing with complex social relations, such as those revealed during the realization of the large scale projects.

In a way, one can say that Christo's works are all built around one central idea: how to do away with the increasing alienation of our culture with a simple manipulation of 'reality' and unite the intellectual and sensual recording mechanisms in a total and all-inclusive experience of existence.

A special quality of Christo's works is their dialectical clarity and legibility. This is already present in the early works but becomes more and more a central theme as the body of works gradually develops. It is reasonable to assume that this desire for clarity and precision comes from Christo's youth in Bulgaria. There he received a thorough schooling in Marxist dialectics whose educational and propagandarizing aims were to systematically project certain social and political ideas.
Size and quantity is an important method of effective communication in a dialectical context and it is, therefore, in line with Christo's schooling that he has used such methods in a long series of public projects. Another outcome of the desire for simplicity and legibility is that in his drawings Christo often uses texts (objective technical and topographical words and numbers) as a support to or explanation of the visual expression.

Another consequence of this desire for clarity is Christo's involvement with the media and mass communication. Many artists of his generation have been preoccupied with mass communication, but for the most part from a critical or analytical position towards mass media as methods for social and political manipulations. Christo's attitude towards mass media is different. Even though Christo never calls upon the media, the work itself calls the media. He uses the media, building them into his works, because an important part of his work is manifested in public projects which deal with and come into existence in a social space like the "Wrapped Public Buildings", "Wrapped Monuments", "Wrapped Coast", "Valley Curtain", "Running Fence", and "Wrapped Walks Ways". Most of these projects have a physical and labour (economic) format, which in itself calls forth the curiosity and interest of the public and media. But, more importantly, these projects include and in fact necessitate the cooperation of political bodies as well as private persons, to obtain permits and collaboration in solving technical, practical, human, legal and financial problems. The mass media is an important part of the communication process.

Christo's large projects begin and end as visual ideas, with the initial idea stems from Christo's hand a series of drawings, collages and scale models. As Christo continues working on the visual and aesthetic aspects of the project, he parallely carries out the collection of technical data, the testing of practical solutions, the choice of the location where the project can be realized most effectively and the presentation of the idea to the public bodies and private concerns whose collaboration is necessary for the realization of the project. These three processes – the preparatory work in the studio, the technical limitations and possibilities, together with the reactions of the environment – work upon each other and are equally valid elements in the project. The drawings, collages, scale models and prints which come into existence in Christo's studio, document the uneven steps in the development process from the first idea to the finished project. At the same time they are elements in the process. They are Christo's method of gathering up and working over the experiences, and channeling his own ideas into the project as it gradually takes on its own independent existence within the frame-work of technical and practical/political circumstances.

These works, including the prints, are indispensable in communicating the idea to the outside world and, this is important, in getting the funds necessary to cover the cost of the projects. Even the pace of the output is decided by Christo's work upon the big projects. For example, there were many prints made in connection with 5,600 Cubicmeter Package, Kassel, in 1968 and Valley Curtain in 1972. These prints have been produced in a tight time schedule and they are less complicated technically than most of his collaged and colored lithographs.

Christo has in common with many other artists of his generation the use of varied graphic techniques as efficient methods of communicating artistic ideas. Like other contemporary colleagues, Christo has also used photographic elements in his prints. The photographs are sometimes used as collage elements or reproduced directly as documentation. In other prints, the photos work as a base for collage-drawings.

The use of photographic and text material is important for Christo's choice of graphic techniques. Most of the prints are silkscreens or lithographs made from metal plates, which are the techniques best suited to reproduction of photographs and texts. Christo has used etching combined with lithography only once, he has not used any of the classic graphic techniques of woodcut and aquatint. The number of colors and the technical complexity of the prints varies and is conditioned more by the character of the subject than by any strictly aesthetic reason.
Christo has a matter-of-fact attitude toward technique. This is distinctly shown in his relation to graphic methods where he takes little heed of graphic conventions but rather follows the procedures which give a maximum visual formulation of his ideas.

Multiplied objects

Christo's 'multiplied objects' are not multiples in the usual sense; that is to say, they are not produced industrially or by a craftsman working from a model made by the artist. They are all made by Christo himself and are, therefore, best characterized with the designation 'original works in series'. That Christo has personally completed every single work in the series gives each example an individual

character. In some series (for example, Magazines Empaquetés) this was the conscious intention; in other series, the individuality developed from the work process itself.

The objects refer to central ideas in Christo's work. For example, his wrapped books, magazines and flowers have a clear connection with the wrapping of other life-size objects, and with his interest in mass media and mass communication. An object can also be an element in a completely special project, as, for example, Wrapped Boxes, where the dispatch of the boxes and their subsequent fate is in itself an action.

Most often the objects have come into being through reaction to external impulses; (for example, the wrapping of the Cologne Cathedral, as an element in the Intermedia Festival in Heidelberg), as elements in fund-raising activities for a work in which Christo is himself involved (for example, Wrapped Modern Art Book) or for enterprises with which Christo sympathizes and would like to support (for example, Journal "Pour" Wrapped and Wrapped Chicago Magazine.)

The production of multiplied objects is far more irregular than that of graphics and several series are only partially completed.

Per Hovdenakk / Jörg Schellmann

Christo, Editionen
(Druckgraphik und Auflagenobjekte)
1964 – 1982

Dank an Jeanne-Claude und Christo
für ihre Hilfe

Alle Arbeiten sind signiert und
numeriert, falls nicht anders angegeben.

Per Hovdenakk / Jörg Schellmann

Christo, Editions
(Prints and Objects in Series)
1964 – 1982

Thanks to Jeanne-Claude and Christo –
their help made this book possible

Unless otherwise stated all works
are signed and numbered.

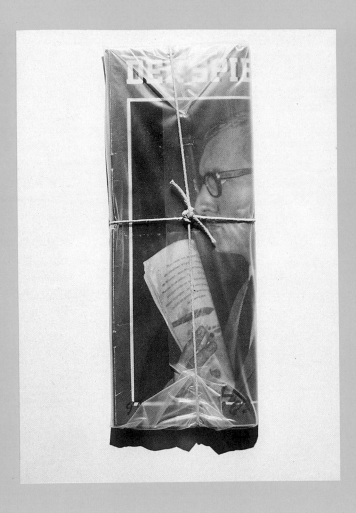

1. Verpackte Zeitschrift „Der Spiegel"

1964
Zeitschrift „Der Spiegel" gefaltet und mit Bindfaden
in transparente Plastikfolie verpackt
Maße: 30 x 13 x 2,5 cm
Auflage: 130 von Christo handgemachte Exemplare
Herausgegeben von Hans Möller, Düsseldorf

Erschienen als Teil der „Edition Original 1", zusammen mit
Auflagenobjekten oder Graphiken von insges. 15 Künstlern.
Jedes Exemplar der Edition enthält eine andere Ausgabe der
Zeitschrift und hat so Originalcharakter.

Christo's erste verpackte Zeitschriften entstanden 1961

1. "Der Spiegel" Magazine Empaqueté

1964
"Der Spiegel" magazine folded and wrapped
in transparent plastic and twine
Size: 30 x 13 x 2.5 cm
Edition: 130 copies, handmade by Christo
Publisher: Hans Möller, Düsseldorf

Published as part of "Edition Original 1", with original works
(in series) or prints by 15 artists. Each number of the edition
contains a different issue of "Der Spiegel" and thus, has an
individual character.

Christo's first Wrapped Magazines were made in 1961

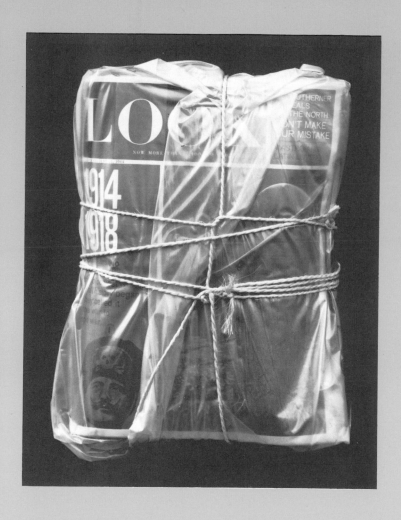

2. Verpackte Zeitschrift „Look"

1965
Zeitschrift „Look", mit Bindfaden und transparenter
Plastikfolie verpackt, aufmontiert auf schwarzer Holzplatte
Maße (der Holzplatte): 56 x 46 x 4 cm
Auflage: 100 von Christo handgemachte Exemplare
Herausgeber: MAT Edition/Galerie Der Spiegel, Köln

Für die Edition wurde jeweils eine andere Ausgabe der Zeitschrift
in transparente Folie (look = sehen) eingepackt.
Das Objekt wurde in der Folge „MAT Edition 2" von Daniel
Spoerri herausgegeben.

2. "Look" Magazine Empaqueté

1965
"Look" magazine wrapped in different ways.
Polyethylene and rope on black wooden support.
Size (of wooden support): 56 x 46 x 4 cm
Edition: 100 copies, handmade by Christo
Publisher: MAT Edition/Galerie Der Spiegel, Cologne

Each piece of the edition contains a different issue of the
magazine, packed in transparent polyethylene (look = see).
The work was published in the series "MAT Edition 2", initiated
by Daniel Spoerri.

3. Verpackte Blume

1965
Plastikrose, mit Bindfaden in transparente Folie verpackt
Maße: ca. 5 x 40,5 x 10 cm
Auflage: 10 (von Christo eingepackte) Exemplare
Herausgegeben von George Maciunas

George Maciunas gab mehrere „Koffer" als Edition mit Arbeiten von Künstlern heraus, die mit Fluxus in Verbindung standen. Christo lernte Maciunas 1958 in Köln kennen, wurde aber — obwohl er an einigen ihrer Aktionen teilnahm — nicht Mitglied der Fluxus-Bewegung.
Die „Verpackte Blume" wurde von Maciunas nie herausgegeben; man fand sie 1978 nach seinem Tod in seinem Archiv.

3. Wrapped Flower

1965
Plastic rose wrapped in polyethylene and twine
Size: approx. 5 x 40.5 x 10 cm
Edition: 10 copies, wrapped by Christo
Publisher: George Maciunas

George Maciunas edited several "valises". Each contained works by the artists connected in one way or other with Fluxus. Christo met Maciunas in Cologne 1958, but never became a member of the Fluxus group, although he took part in some of their activities.
The "Wrapped Flower" was never used by Maciunas. The edition was found in his archives after his death in 1978.

4. Verpackte Kartons

1966
Karton, verpackt mit braunem Packpapier und Bindfaden
Maße: 20 x 20 x 20 cm
Auflage: 100 Exemplare,
eingepackt von Studenten einer Design-Klasse
am Macalester College in St. Paul, Minnesota
Herausgegeben von der Minneapolis School of Art
und der Walker Art Center's Contemporary Arts Group.

Ungefähr 20 Kartons wurden von den Empfängern geöffnet; in jedem Karton lag ein Zertifikat:

4. Wrapped Boxes

1966
Box wrapped with brown paper and twine
Size: 20 x 20 x 20 cm
Edition: 100 copies,
handmade by students in a design class at
Macalester College, St. Paul, Minnesota
Publisher: Minneapolis School of Art and the
Walker Art Center's Contemporary Arts Group.

Approximately 20 Wrapped Boxes were opened by the recipients and they found this certificate inside:

The package you destroyed was wrapped according to my instructions in a limited edition of 100 copies for members of Walker Art Center's Contemporary Arts Group. It was issued to commemorate my "14130 Cubic Feet Empaquetage 1966" at the Minneapolis School of Art, a project co-sponsored by the Contemporary Arts Group.

Christo

This is no. _____ of 100

1966 Proof artist for Jeanne Claude

Anlaß für die Aktion war die Realisierung von Christo's „12.920 Kubikmeter-Paket" an der Minneapolis School of Art. Die Kartons selbst hatten keinerlei Wert als Kunstgegenstände; das Wesentliche war der Versand (an Mitglieder der Contemporary Arts Group). Das Öffnen zerstörte sie als Kunstwerke.

The occasion for the event was Christo's "42,390 Cubic Feet Package" at Minneapolis School of Art. The boxes themselves are ordinary ones and have no special value as art objects. The essential part of the project is the mailing of the boxes (to members of the Contemporary Arts Group). If the boxes were opened by the recipients, they were destroyed as objects.

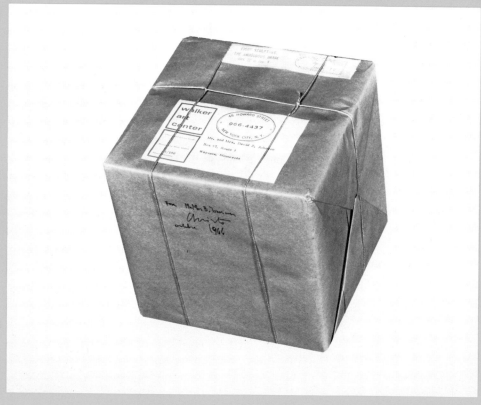

5. Schaufenster-Gang, Projekt

1967/68
Siebdruck und Offset, Plexiglas, aufklappbar
Maße: 71 x 56 cm
Auflage: 75 Exemplare
Drucker: Hans-Peter Haas, Stuttgart (Siebdruck);
Haarhaus, Köln (Offset)
Herausgeber: Documenta Foundation / Galerie Der Spiegel, Köln

Die Edition wurde herausgegeben, um mit dem Verkauf zur
Finanzierung der Documenta 4 beizutragen.

5. Corridor Store Front, Project

1967/68
Screenprint and offset, plexiglass, to be opened
Size: 71 x 56 cm
Edition: 75 copies
Printer: Hans-Peter Haas, Stuttgart (Silkscreen),
Haarhaus, Cologne (Offset)
Publisher: Documenta Foundation / Galerie Der Spiegel, Cologne

The print was published to raise money for the Documenta 4
Exhibition.

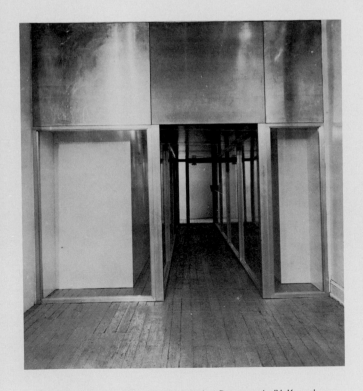

Corridor Store Front 1867–68 exhibited at Documenta IV, Kassel

6. Schaufenster-Gang, Projekt

1968
Farbsiebdruck, auf Holzplatte und Plexiglas aufgezogen,
aufklappbar, mit Scharnieren
Maße: 70 x 55 cm
Auflage: 100 Exemplare (+ 25 A.P.)
Drucker: Hans-Peter Haas, Stuttgart
Herausgeber: Verlag Gerd Hatje, Stuttgart

Herausgegeben zur Finanzierung des Buches „Christo" von
Lawrence Alloway, erschienen bei Hatje, Stuttgart und Abrams,
New York.

6. Corridor Store Front, Project

1968
Color screenprint, mounted on board and plexiglass,
with hinges to be opened
Size: 70 x 55 cm
Edition: 100 copies and 25 artist's proofs
Printer: Hans-Peter Haas, Stuttgart
Publisher: Verlag Gerd Hatje, Stuttgart

Made for funding the publication of the book "Christo" by
Lawrence Alloway, co-published by Verlag Gerd Hatje, Stuttgart
and Harry N. Abrams, New York.

7. Verpackte Rosen

1968
Drei Plastikrosen, mit Bindfaden in transparente
Folie eingepackt
Maße: 56 x 10 x 13 cm
Auflage: 75 von Christo verpackte Exemplare
Herausgegeben vom Institute of Contemporary Art,
Universität von Pennsylvania, Philadelphia

Das Objekt entstand anläßlich der Christo-Ausstellung im Institute
of Contemporary Art zur Finanzierung des Projekts „Mastaba
aus 1240 Ölfässern", das für die Ausstellung realisiert wurde.

7. Wrapped Roses

1968
Three plastic roses, wrapped with polyethylene and twine
Size: 56 x 10 x 13 cm
Edition: 75 copies, handmade by Christo
Publisher: Institute of Contemporary Art,
University of Pennsylvania, Philadelphia

Published on the occasion of Christo's exhibition in the Institute
of Contemporary Art, to help the Institute raise funds to cover
the expenses of the temporary installation of "1,240 Barrels
Mastaba", realized in the exhibition.

8. Verpackte Rosen

1968
Plastikrosen, mit Bindfaden in transparente Folie eingepackt
Maße: 65 x 9 x 16 cm
Auflage: 75 von Christo handgemachte Exemplare
(wohl nur 45 hergestellt)
Herausgeber: Richard Feigen Graphics, New York

8. Wrapped Roses

1968
Plastic roses, wrapped with polyethylene and twine
Size: 65 x 9 x 16 cm
Edition: 75 copies, handmade by Christo
(probably only 45 were made),
Publisher: Richard Feigen Graphics, New York

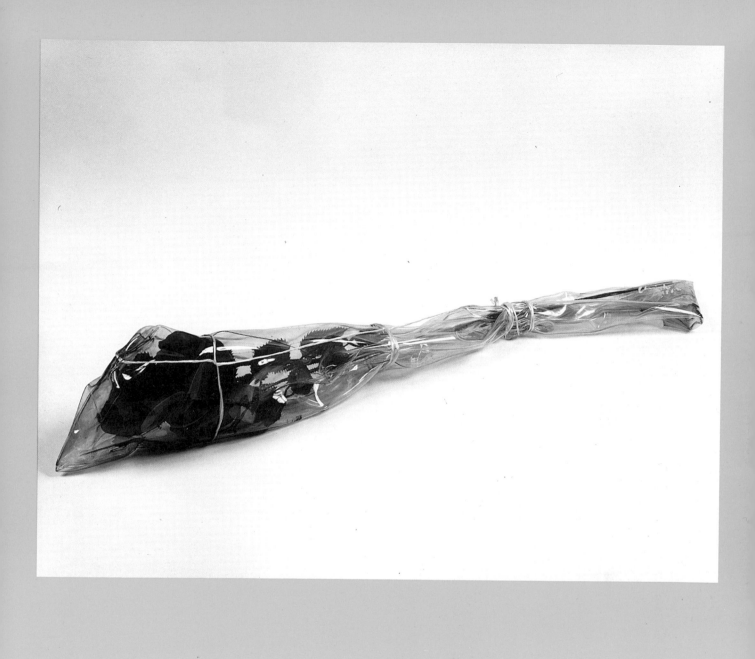

9. 5600 Kubikmeter-Paket, Kassel 1968

1968
Photographie (s/w), 60 x 50 cm
Auflage: 50 Exemplare
Photograph: Klaus Baum
Herausgeber: Christo

Das Photo, das die Errichtung des 5600 Kubikmeter-Pakets auf der Documenta 4 in Kassel zeigt, wurde zur Finanzierung des Projektes herausgegeben; ein Teil der Auflage wurde von der Documenta-Foundation vertrieben.

Das Kasseler „Luft-Paket" stand zwei Monate lang im barocken Garten der „Orangerie", einer künstlichen Parklandschaft aus dem 18. Jahrhundert.
Höhe: 85 m
Durchmesser: 10 m
Gewicht: 6,3 to
Hülle: ca. 2000 qm Trevira-Stoff mit PVC-Überzug
Seile: 3660 m Kunststoffseil, 2,5 cm ⌀
6 Beton-Fundamente, angeordnet in einem Kreis von 275 m Durchmesser, Gesamtgewicht: 183 to
Errichtet mit Hilfe von 5 Kranwagen am 3. August 1968 von 4 bis 14 Uhr
Standdauer: 75 Tage
Ingenieur: Dimiter Zagoroff
Das Projekt wurde von Christo finanziert.

9. 5,600 Cubicmeter Package, Kassel 1968

1968
Photograph (b/w), 60 x 50 cm
Edition: 50 copies
Photographer: Klaus Baum
Publisher: Christo

The photo, which shows 5,600 cubicmeter package during its erection at Documenta 4 in Kassel, was published to raise money for the project. Part of the edition was sold through the Documenta Foundation.

The Kassel "Air Package" was placed in the baroque garden of the Orangerie, built in the 18th Century, a man-made landscape of a typical urban character.
Height: 280 feet
Diameter: 33 feet
Weight: 14,000 pounds
Skin: 22,000 square feet of Trevira fabric coated with PVC
Ropes: 12,000 feet of one inch diameter polyethylene
6 concrete foundations on a 900 feet diameter circle,
Total weight: 180 tons
Erected between 4:00 AM and 2:00 PM on August 3rd, 1968, using 5 Truck-Cranes
Duration: 75 days
Engineer: Dimiter Zagoroff
The project was financed by Christo

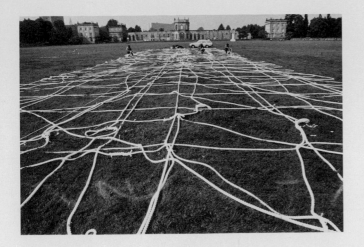

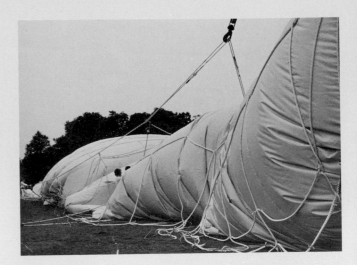

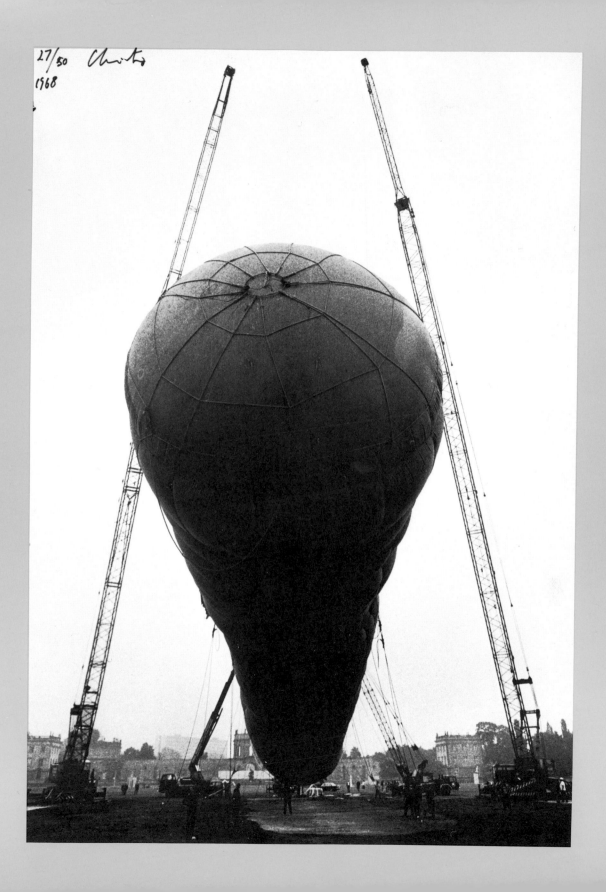

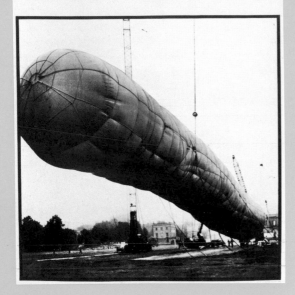

die grösste flexible hülle der welt »christoprojekt« documenta 4
herstellung: wülfing & hauck 3504 oberkaufungen / kassel

10. 5600 Kubikmeter-Paket, Kassel

1968
Siebdruck auf Plastikfolie (einige auf Papier)
a) schwarz auf weiß, b) schwarz auf rot,
c) schwarz auf silber
Maße: 135,5 x 85,3 cm
Auflage: insgesamt 150 Exemplare
Drucker: Julius Kress, Kassel
Photograph: Klaus Baum
Herausgeber: Wülfing & Hauck, Kassel

Christo signierte diese Edition, um Herrn Wülfing und Herrn
Hauck dafür zu danken, daß sie, als er bei deren Firma das
Material für die Hülle des Luft-Paketes bestellte, von ihm einen
vordatierten Scheck akzeptierten, obwohl sie erfahren hatten,
daß zur Zeit der Bestellung kein Geld auf Christo's Konto war.

10. 5,600 Cubicmeter Package, Kassel

1968
Screenprint on mylar (some copies on paper)
a) black on white b) black on red, c) black on silver
Size: 135.5 x 85.3 cm
Edition: altogether 150 copies
Printer: Julius Kress, Kassel
Photographer: Klaus Baum
Publisher: Wülfing & Hauck, Kassel

Christo signed this edition to thank Mr. Wülfing and Mr. Hauck
for having taken a chance when they accepted a postdated
check at the time Christo ordered from them the Trevira fabric
Envelope for the Air Package, even though they had been told
that there were no funds in the bank account at the time of the
purchase order.

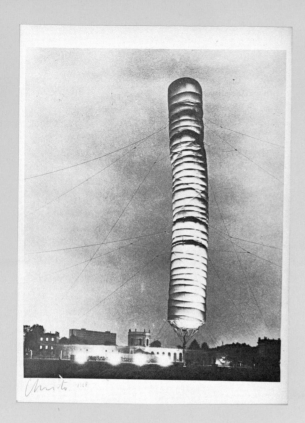

11. 5600 Kubikmeter-Paket, Kassel

1968
Farboffset, 57,8 x 45,3 cm
Auflage: 500 Exemplare – nur 200 signiert, nicht numeriert
Papier: 120 g Offset
Drucker: Gebr. Zahnwetter, Sandershausen/Kassel
Photograph: Klaus Baum
Herausgeber: Griffelkunst, Hamburg

11. 5,600 Cubicmeter Package, Kassel

1968
Color offset print, 57.8 x 45.3 cm
Edition: 500 copies – only 200 signed, not numbered
Paper: 120 g offset paper
Printer: Gebrüder Zahnwetter, Sandershausen/Kassel
Photographer: Klaus Baum
Publisher: Griffelkunst, Hamburg

12. Pläne und Realisierungen 1961–68

1968
Kartenbox mit Modell und 10 Grafikblättern:
a. Modell des „5600 Kubikmeter-Pakets", von Christo selbst hergestellt aus Plastikgewebe, Bindfaden und Metallgestell, auf grünem Filztuch. Maße des Pakets: 68 cm x 6 cm ∅
b. Farbsiebdruck „Mauer auf Ölfässern – Der eiserne Vorhang, Rue Visconti, Paris, Juni 1962"
c. Farbsiebdruck „Verpackte Hochhäuser von Manhattan, Broadway 2 and Exchange Place 20" 1964–66 (vgl. Nr. 34 und 61)
d. Farbsiebdruck „5600 Kubikmeter-Paket", Kassel 1968
e. Siebdruck, aufklappbar, mit Plexiglas „Schaufenster-Gang", Kassel, Documenta 4, 1968
f., g. Siebdrucke „1200 Kubikmeter-Paket", Minneapolis, 1966
h. Siebdruck (nach Zeichnung) „4716 Metalltonnen", Projekt für die Nationalgalerie, Rom
i. Siebdruck (nach Photomontage) „Verpacktes öffentliches Gebäude", Projekt, 1961
j. Siebdruck (nach Photomontage) „Verpacktes öffentliches Gebäude", Projekt, 1963 (vgl. Nr. 22)
k. Siebdruck (nach Modell) „Nationalgalerie, verpackt", Projekt für Rom 1967
Maße der Blätter: 70 x 54,2 cm
Auflage: 100 Exemplare
Papier: Bristol-Karton
Drucker: Hans Peter Haas, Stuttgart (Siebdruck); Haarhaus, Köln (Offset)
Photographen: Klaus Baum, Carrol T. Hartwell, Jacques Dominique Lajoux, Raymond de Seynes, Shunk-Kender
Herausgeber: Galerie Der Spiegel, Köln

Die Edition wurde aufgelegt, um Christo's Teilnahme an der Documenta 4 mitzufinanzieren. In der Mappe wird das Kassler Projekt zu anderen großen realisierten und nicht realisierten Projekten in Bezug gesetzt. Außerdem stellt sie die Anfänge der Stadt-Projekte vor: „Wand aus Ölfässern – Eiserner Vorhang", Rue Visconti, 1962 und Vorschläge zum Verpacken der Ecole Militaire (1961) und des Arc de Triomphe (1963), alle in Paris.

12. Proposals and Realizations 1961–68

1968
Box, designed by Christo, with Scale Model and 10 prints:
a. Scale Model of "5,600 Cubicmeter Package", handmade by Christo of plastified fabric, twine and metal on green felt. Size of package: 68 cm x 6 cm ∅
b. Color screenprint "Wall of Oil-Drums – The Iron Curtain, Rue Visconti, Paris, June 1962"
c. Color screenprint "Lower Manhatten Packed Buildings, Number 2 Broadway and Number 20 Exchange Place", 1964–66 (see Nos. 34 and 61)
d. Color screenprint, "5,600 Cubicmeter Package", Kassel 1968
e. Screenprint, to be opened, with cut-out and plexiglass "Corridor Store Front", Kassel, Documenta 4, 1968
f., g. Screenprints "42,390 Cubic Feet Package", Minneapolis, 1966
h. Screenprint (from a drawing) "Toneaux Métalliques", project for Galleria Nazionale, Rome
i. Screenprint (of photomontage) "Edifice Public Empaqueté", project 1961
j. Screenprint (of photomontage) "Edifice Public Empaqueté", project 1963 (see No. 22)
k. Screenprint (of a scale model) "Galleria Nazionale, Wrapped", project for Rome 1967
Size of prints: 70 x 54.2 cm
Edition: 100 copies
Paper: Bristol
Printer: Hans Peter Haas, Stuttgart (Silkscreen); Haarhaus, Cologne (Offset)
Photographers: Klaus Baum, Carrol T. Hartwell, Jacques Dominique Lajoux, Raymond de Seynes, Shunk-Kender
Publisher: Galerie Der Spiegel, Cologne

The portfolio was published to help fund Christo's participation in Documenta 4. In the portfolio the Kassel project is presented in a context of related large scale projects some already realized, some not. Also it gives the historic development of the urban projects, by presenting the "Wall of Oil Barrels – Iron Curtain", Rue Visconti, Paris, June 27th, 1962 and the proposals for Wrapping the Ecole Militaire, Paris, 1961 and the Arc de Triomphe, Paris, 1963.

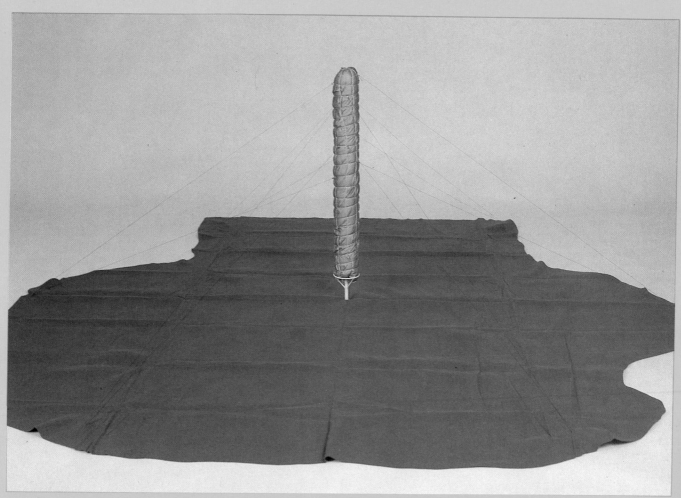

a

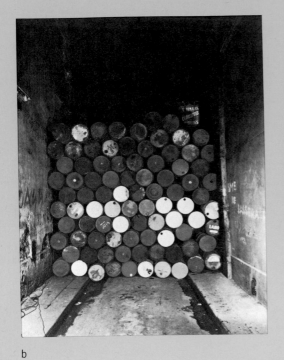

b

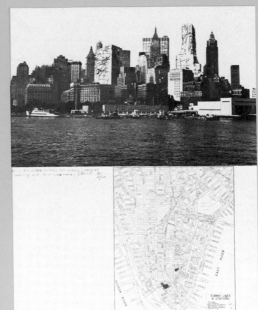

c

d

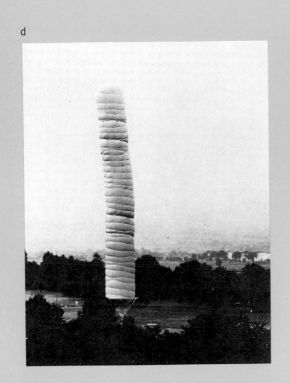

e

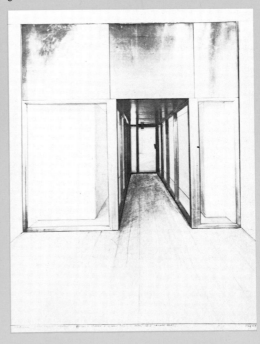

f

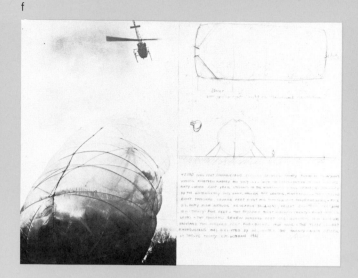

g

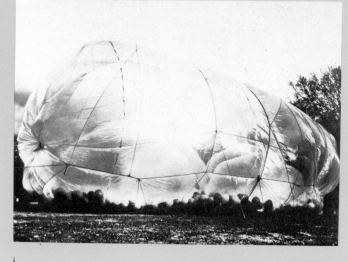

h

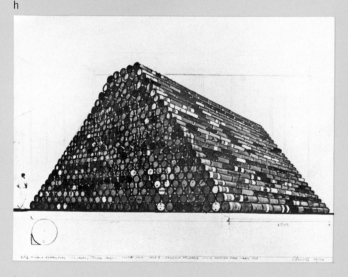

i

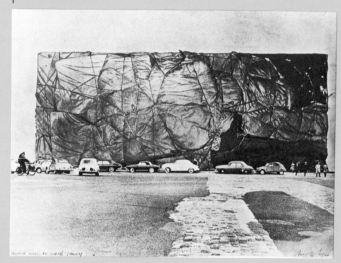

j

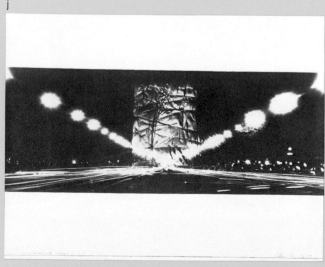

k

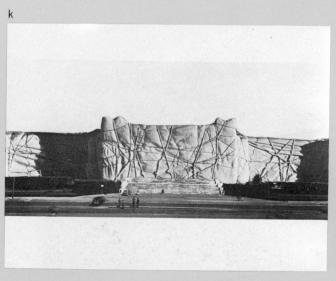

13. Verpacktes Bild

1968
Offset, beidseitig, ausgestanzt
Maße: 82 x 60 cm
Auflage: 100 Exemplare
Papier: 150 g Offset
Drucker: Johnson Printing Co., Minneapolis
Photograph: Shunk-Kender
Herausgeber: Contemporary Art Lithographers, Minneapolis

Herausgegeben anläßlich der Verpackung des Museum of Contemporary Art, Chicago (vgl. Nr. 29). Um Materialien zum Verpacken des Gebäudes auszuprobieren, verpackte Christo mehrere Bilder mit verschiedenen Stoffen. Eines dieser Objekte wurde für die Graphik beidseitig reproduziert. Das Motiv wurde auch als Plakat für das Projekt benutzt.

13. Wrapped Painting

1968
Offset print on both sides, cut-out
Size: 82 x 60 cm
Edition: 100 copies
Paper: 150 g offset paper
Printer: Johnson Printing Co., Minneapolis
Photographer: Shunk-Kender
Publisher: Contemporary Art Lithographers, Minn.

Published on the occasion of Christo wrapping The Museum of Contemporary Art, Chicago (see No. 29). Christo tried out various materials for the wrapping of the museum. He wrapped several paintings with different fabrics. A photograph of one of the paintings was used for the print. Both sides of the wrapped painting are reproduced. The same image was used as a poster for the event.

14. Verpackung der Kunsthalle Bern

1968
Offset, 98,5 x 69 cm
Auflage: 200 Exemplare
Photograph: Frank Donell
Herausgeber: Kunsthalle Bern

Projekt: siehe Nr. 27

14. Kunsthalle Bern, Wrapped

1968
Photo offset print, 98.5 x 69 cm
Edition: 200 copies
Photographer: Frank Donell
Publisher: Kunsthalle Bern, Switzerland

Project: see No. 27

15. Verpackung der Kunsthalle Bern

1969
Siebdruck auf Gold- bzw. Silberfolie, auf Karton
aufgezogen
Maße: 35 x 50 cm (gold), einige 25 x 36 cm (silber)
Auflage: 54 Exemplare
Drucker: Druckerei Ebner, Aglasterhausen
Photograph: Thomas Cugini
Herausgeber: Edition Staeck, Heidelberg

Herausgegeben zur Intermedia 1969, Heidelberg
Projekt: siehe Nr. 27

15. Kunsthalle Bern, Wrapped

1969
Screenprint on gold and silver foil,
mounted on cardboard
Size: 35 x 50 cm (gold) and some 25 x 36 cm (silver)
Edition: 54 copies
Printer: Druckerei Ebner, Aglasterhausen
Photographer: Thomas Cugini
Publisher: Edition Staeck, Heidelberg

Published for the Intermedia 1969, Heidelberg
Project: see No. 27

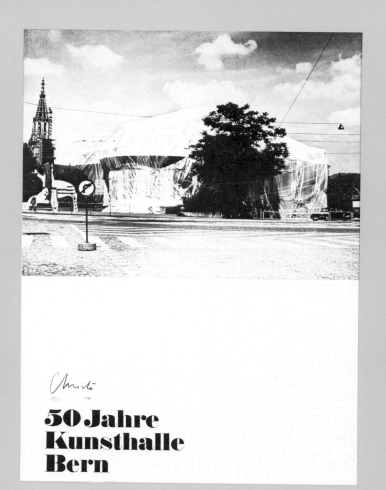

Christo
15/... ...

50 Jahre
Kunsthalle
Bern

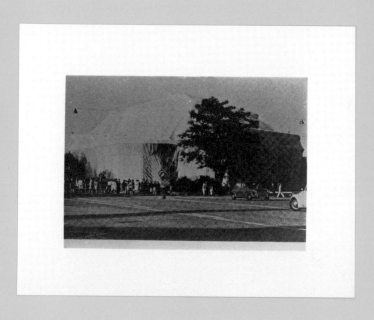

16. 56 gestapelte Fässer

1969
Farbsiebdruck, 70 x 50 cm
Auflage: 60 Exemplare (+ 5 A. P.)
Papier: 150 g-Karton
Drucker: Rolf Weeber, Breda
Photograph: Pieter Mol, Breda
Herausgeber: Galerie Seriaal, Amsterdam

Das Blatt wurde nach einem Foto des Objekts „56 gestapelte Fässer" gedruckt, das Christo 1966 für die holländischen Sammler Mia und Martin Visser realisierte. Das Objekt wurde 1975 dem Reichsmuseum Kröller-Müller, Otterlo gestiftet.

16. 56 Barrels Construction

1969
Color Screenprint, 70 x 50 cm
Edition: 60 copies and 5 artist's proofs
Paper: 150 g
Printer: Rolf Weeber, Breda
Photographer: Pieter Mol, Breda
Publisher: Galerie Seriaal, Amsterdam

The print is based on a photo of the "56 Stacked Barrels", made in 1966 for the Dutch collectors Mia and Martin Visser, Bergeyk. The structure was donated to the Rijksmuseum Kröller-Müller, Otterlo.

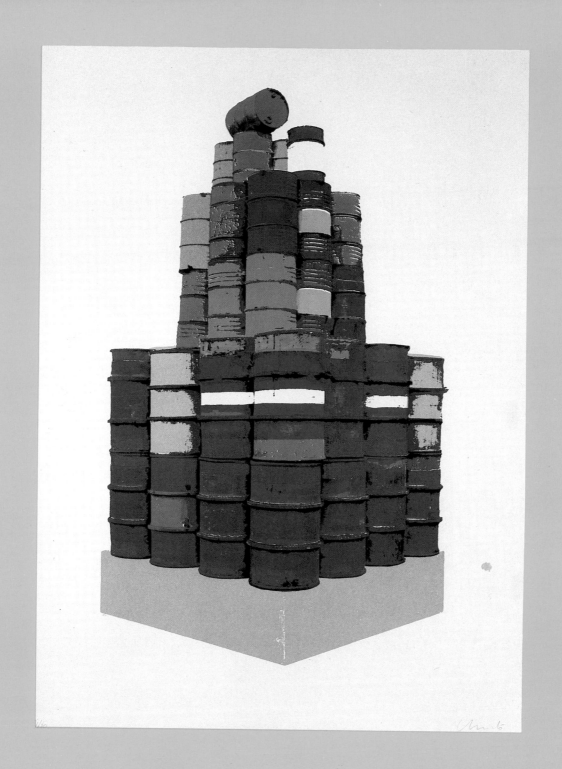

17. Verpackte Treppe

1969
Offset (s/w), beidseitig, 58 x 38,5 cm
Auflage: 100 Exemplare (+ 10 A. P.)
Papier: 300 g Cromote
Drucker: Veereman, Deuvre-Antwerpen
Photograph: Harry Gruyaert
Herausgeber: Wide White Space Gallery, Antwerpen

Der Druck wurde für eine Christo-Ausstellung in der Galerie
Wide White Space gemacht. Er zeigt die alte flämische Treppe
der Galerie, die Christo – wie die gesamten Galerieräume – mit
Abdeckplanen verpackt hatte. Die Rückseite des Druckes zeigt
die Treppe in unverpacktem Zustand.

17. Wrapped Staircase

1969
Offset print (b/w), 58 x 38.5 cm
Edition: 100 copies and 10 artist's proofs
Paper: 300 g Cromote
Printer: Veereman, Deuvre-Antwerp
Photographer: Harry Gruyaert
Publisher: Wide White Space Gallery, Antwerp

The print was made for Christo's exhibition in Wide White Space
Gallery. It shows the photographic image of his wrapping of the
Flemish staircase of the gallery. The entire inside of the gallery
was wrapped with "drop-cloths" – linen used in the US by
interior house painters. The reverse side of the print shows the
stairway as it is normally.

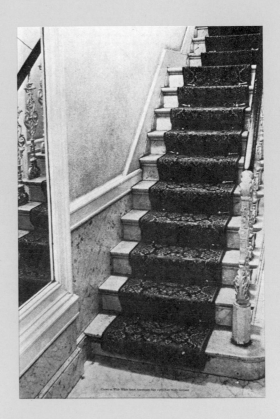

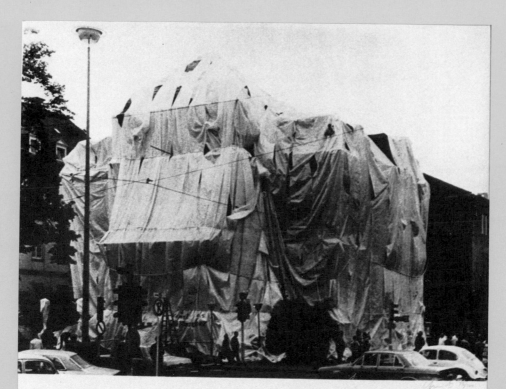

AMERICA HOUSE WRAPPED Christo 1969

20. Verpackte Küste – Kleine Bucht, Australien

1969
Offset (s/w), 122 x 92 cm
Auflage: 50 Exemplare
Papier: 150 g Offset
Drucker: Haarhaus, Köln
Photograph: Shunk-Kender
Herausgeber: Galerie Der Spiegel, Köln

Das Blatt entstand für die Ausstellung der Dokumentation des Projekts „Wrapped Coast" in der Galerie Der Spiegel, Köln

Projekt: siehe Nr. 42

20. Wrapped Coast – Little Bay, Australia

1969
Offset print (b/w), 122 x 92 cm
Edition: 50 copies
Paper: 150 g offset paper
Printer: Haarhaus, Cologne
Photographer: Shunk-Kender
Publisher: Galerie Der Spiegel, Cologne

Made for the exhibition of the Wrapped Coast documentation at the Galerie Der Spiegel in Cologne

Project: see No. 42

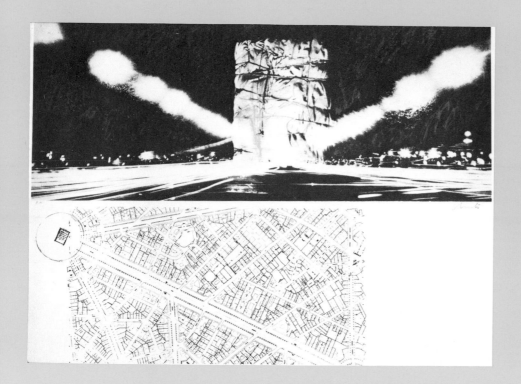

22. Verpacktes öffentliches Gebäude,
Projekt für den Arc de Triomphe, Paris

1970
Farblithographie, 50 x 65 cm
Auflage: 300 Exemplare (+ 20 A. P.)
Papier: Arches Bütten
Drucker: Atelier Clot, Bramsen et Georges, Paris
Photograph: Shunk-Kender
Herausgeber: Prisunic, Paris

22. Packed Public Building,
Project for Arc de Triomphe, Paris

1970
Color lithograph, 50 x 65 cm
Edition: 300 copies and 20 artist's proofs
Paper: Arches
Printer: Atelier Clot, Bramsen et Georges, Paris
Photographer: Shunk-Kender
Publisher: Prisunic, Paris

23. Verpackter Baum

1970
Farbsiebdruck, 62 x 83 cm
Auflage: 150 Exemplare (+ 15 A. P.)
Papier: Bristol Karton
Drucker: Hans-Peter Haas, Stuttgart
Photograph: Shunk-Kender
Herausgeber: Galerie Der Spiegel, Köln

Erschienen in der Mappe „Spiegel 70" zum 25-jährigen Bestehen der Galerie Der Spiegel, zusammen mit Blättern von 11 anderen Künstlern. (siehe auch Nr. 56)

Der erste „Verpackte Baum" entstand 1966 in Holland für die Christo-Ausstellung im Stedelijk-van-Abbe-Museum, Eindhoven.

23. Wrapped Tree

1970
Color screenprint, 62 x 83 cm
Edition: 150 copies and 15 artist's proofs
Paper: Bristol
Printer: Hans-Peter Haas, Stuttgart
Photographer: Shunk-Kender
Publisher: Galerie Der Spiegel, Cologne

Included in the portfolio "Spiegel 70" published for the 25th anniversary of Galerie Der Spiegel.
(see also No. 56)

The first lifesize "Packed Tree" was made in Holland, in 1966, as part of Christo's exhibition at the Stedelijk-van-Abbe-Museum, Eindhoven.

24. Projekt Monschau

1971
„Do-it-yourself-Katalog" zum Monschau-Projekt.
Kartonbox. Inhalt: Signierter Paketaufkleber, Rolle Bindfaden, Plastik-Andenken der Burg Monschau, 2 Photos (s/w) von Christo-Zeichnungen, 2 Photos der verpackten Kartonbox, ein Stück des grauen Plastik-gewebes mit dem sie eingepackt wurde, 19 Informations-blätter über das Projekt
Maße der Box: 23 x 16,5 x 16,5 cm
Auflage: 150 Exemplare
Herausgeber: Kunstkreis Monschau

Der Käufer konnte aus dem Katalog selbst ein (verpacktes) Objekt, signiert von Christo, machen.

Die Burg Monschau wurde am 29. September 1971 verpackt, während Christo in Rifle, Colorado am Valley Curtain Projekt arbeitete. Er hatte seinen Freund Willy Bongard gebeten, die Ausführung zu leiten

24. Monschau Project

1971
"Do-it-yourself-Catalogue" for the Monschau project.
Cardboard box containing:
Signed postal sticker, ball of twine, plastic bubble souvenir model of Burg Monschau, Germany, two b/w photos of Christo's drawings for the wrapping, two photos of the box wrapped, piece of grey polypropylene fabric used for the wrapping, 19 sheets of information about the project.
Size of the box: 23 x 16.5 x 16.5 cm
Edition: 150 copies
Publisher: Kunstkreis Monschau

The catalogue could be transformed by the visitor himself into an art object signed by Christo.

The wrapping of Burg Monschau took place on September 29th 1971, while Christo was in Rifle, Colorado, working at the Valley Curtain project. Christo authorized his friend, Willy Bongard, to supervise the Wrapping of the Castle in Monschau.

WRAPPED TREE (PROJECT) about 300' height oil drawing box 3'6"

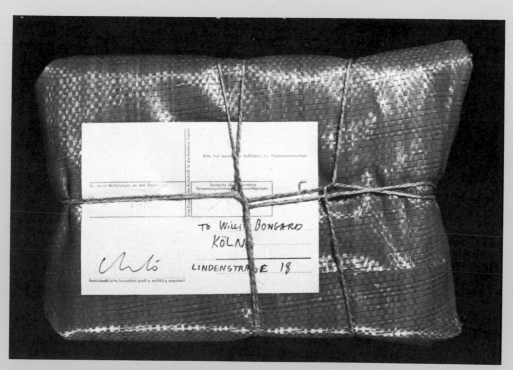

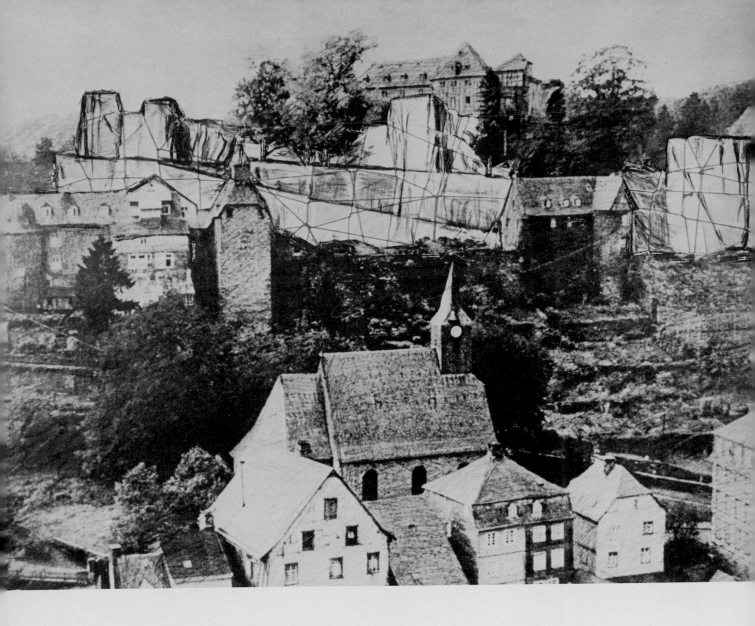

"Curtains for Monschau – Rur River – project for September 1971 in Monschau" collage 1971 (detail), 71 x 56 cm

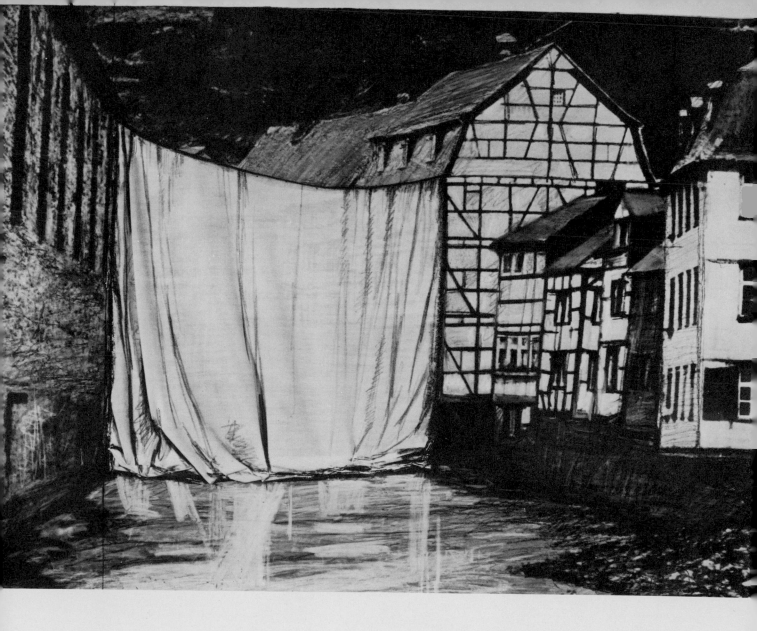

"Wrapped Schloß, project for Monschau", collage 1970 (detail), 71 x 56 cm

25. (Einige) nicht realisierte Projekte

1971
Mappe mit 5 Blättern
a. Farblithographie mit Collage (Stoff, Bindfaden, Folie) „Verpacktes Whitney Museum, New York, Projekt", 1968
b. Farblithographie, collagiert mit Photo und Plan „Verpacktes Museum of Modern Art (Rückseite), Projekt für New York", Juni 1968
c. Farblithographie „Verpacktes Museum of Modern Art (Vorderseite), Projekt für New York", Juni 1968 (Photomontage)
d. Farblithographie „Allied Chemical-Hochhaus, Projekt für Times Square 1, New York", 1968
e. Farblitographie „Allied Chemical-Hochhaus, Projekt für Times Square 1, New York", 1968 (Photomontage)
Maße: 73 x 57,5 cm
Auflage: 100 Exemplare (+ 10 A. P. + 10 S. P.)
Photograph: Shunk-Kender und Ferdinand Boesch
Drucker und Herausgeber: Landfall Press, Chicago

Christo schlug das Verpacken des Whitney Museums für dessen Skulpturen-Biennale 1968 vor. Der Plan stieß aber auf wenig Begeisterung und wurde daher nicht verwirklicht.

Der Plan, das Museum of Modern Art zu verpacken, wurde von Christo 1968 lanciert, als das Museum die Ausstellung „Dada, Surrealsimus und deren Auswirkungen" zeigte. Christo wollte das Museum einpacken, vor dem Museum eine Mauer aus Ölfässern quer über die 53. Straße bauen und in der Eingangshalle des Museums eine „Mastaba" (vgl. Nr. 49) aus Fässern errichten. Da zu dieser Zeit einige Demonstrationen in den Straßen New Yorks stattfanden, gaben die städtischen Behörden und Versicherungen nicht die erforderlichen Genehmigungen, da sie neue Demonstrationen befürchteten.
Das Modell, das für Blatt c) der Mappe benutzt wurde, befindet sich in der Sammlung des Museum of Modern Art, New York.

Das Gebäude Times Square 1 fand Christo so interessant, daß er wiederholte Male versuchte, von den (wechselnden) Besitzern die Genehmigung zum Verpacken zu bekommen – ohne Erfolg.

25. (Some) Not Realized Projects

1971
Portfolio with 5 prints:
a. Color lithograph with collage (fabric, twine, rope, polyethylene) "The Whitney Museum, New York, packed", project, 1968
b. Color lithograph, collaged with map and photograph "The Museum of Modern Art, Wrapped (Rear), project for New York", June 1968
c. Color lithograph "The Museum of Modern Art, Wrapped (Front), project for New York", June 1968 (Photomontage)
d. Color lithograph "Allied Chemical Tower, Packed, project for Number 1, Times Square, New York", 1968
e. Color lithograph "Allied Chemical Tower, Packed, project for Number 1, Times Square, New York", 1968 (Photomontage)
Size: 73 x 57.5 cm
Edition: 100 copies, 10 artist's proofs and 10 subscriber's proofs
Photographer: Shunk-Kender and Ferdinand Boesch
Printer and Publisher: Landfall Press, Chicago

The wrapping of the Whitney Museum of American Art, New York was suggested for the museum's Sculpture Biennale in 1968 but there was little enthusiasm for it in the museum and the project was, therefore, never realized.

The proposal to wrap the Museum of Modern Art, New York, was launched in 1968 when the museum showed the exhibition "Dada and Surrealism and their Heritage". The idea was to wrap the museum and build a wall of oil barrels outside the museum across 53rd street and a mastaba of barrels in the main hall of the museum. At the time there were a number of street demonstrations in New York and the City authorities and insurance companies did not dare give permission for the project for fear that it would lead to new demonstrations.
The 3D Scale Model used in the print c) of the portfolio is in the collection of the Museum of Modern Art, New York.

The building Number 1, Times Square was of great interest to Christo. He approached the various owners of the building several times to get permission to do the wrapping, without sucess.

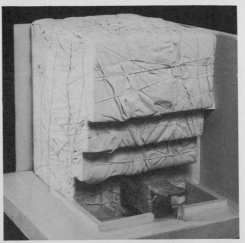

Scale model "The Whitney Museum, New York, packed", 1968

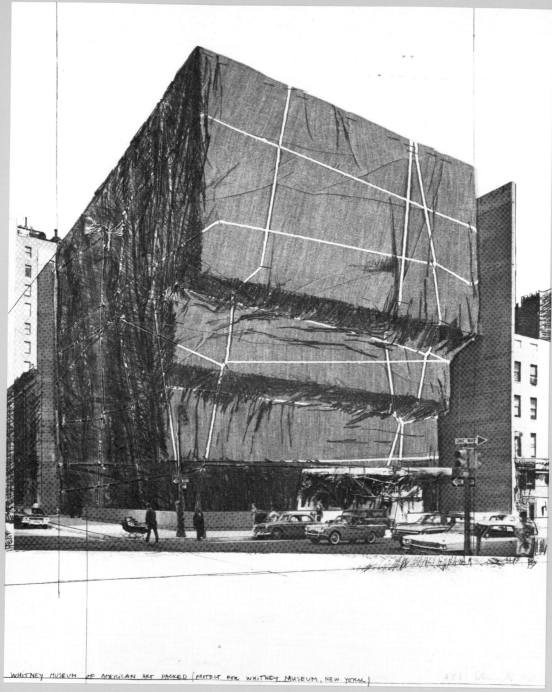

WHITNEY MUSEUM OF AMERICAN ART PACKED (PROJECT FOR WHITNEY MUSEUM, NEW YORK)

a

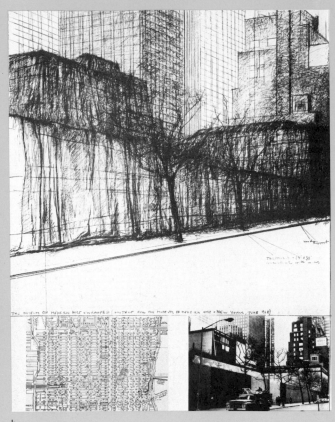

b

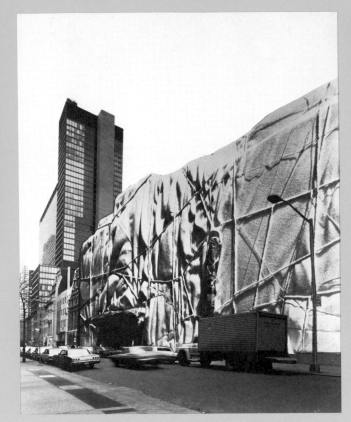

c

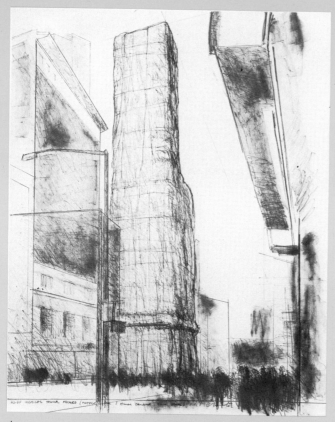

d

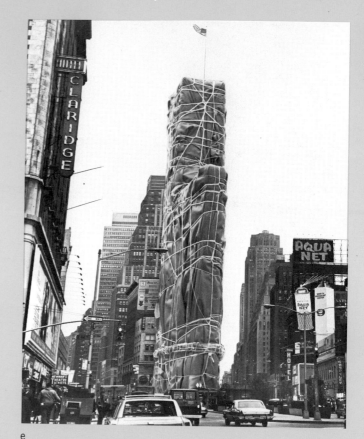

e

26. Verpacktes Leonardo-Denkmal, Mailand

1971
a. Lichtdruck, collagiert mit Stoff und Bindfaden
b. Farblithographie und Lichtdruck
c. Farblichtdruck (nach einem Photo)
Maße: 74,5 x 55,5 cm
Auflage: a mit c je 99 Exemplare
zusätzlich b mit c je 900 Exemplare
Papier: Rives Couronne Bütten
Drucker: Matthieu AG, Zürich
Photograph: Shunk-Kender
Herausgeber: Edition 999, Zürich

Die Blätter wurden zur Finanzierung des Valley Curtain Projekts produziert.

Christo verpackte das Denkmal für Leonardo da Vinci im Jahre 1970. Zwei Tage nach ihrer Fertigstellung wurde die Verpackung während einer politischen Kundgebung in Brand gesteckt. Dieses Projekt und die Verpackung des Denkmals für Vittorio Emmanuele auf dem Domplatz (siehe Nr. 43) waren Christo's Beitrag zu einer großen Ausstellung über den „Nouveau Réalisme" in Mailand. Christo gehörte zwar nie zur Gruppe der „Nouveau Réalistes", hatte aber öfters zusammen mit ihnen ausgestellt.

26. Wrapped Monument to Leonardo, Milan

1971
a. Collotype collaged with fabric and twine
b. Color lithograph and collotype
c. Color collotype (from a photograph)
Size: 74.5 x 55.5 cm
Editions: a) with c) 99 copies each
plus b) with c) 900 copies each
Paper: Rives Couronne
Printer: Matthieu, Zürich
Photographer: Shunk-Kender
Publisher: Edition 999, Zürich

The prints were published to raise money for the Valley Curtain Project.

The wrapping of the Monument to Leonardo da Vinci on Piazza Scala in Milan took place in 1970. Two days after the wrapping had been completed, the monument was set on fire during a political manifestation. The project was part of a large presentation of Nouveau Réalisme, organized by the city of Milan. During this exhibition, Christo also wrapped the Monument to Vittorio Emmanuele, Piazza del Duomo, Milan (see No. 43). Christo never belonged to the "Nouveaux Réalistes" group, but he has exhibited with them on several occasions.

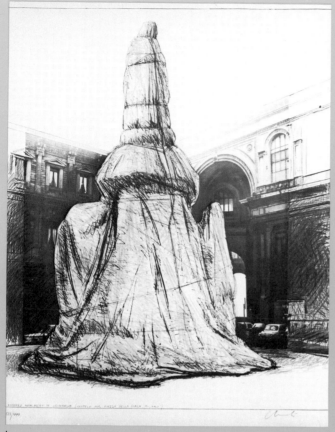

b

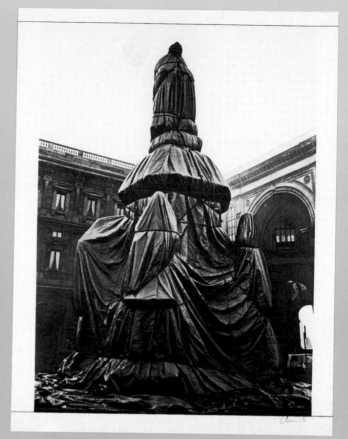

c

27. Verpackung der Kunsthalle Bern

1972
Mappe mit 4 Blättern
a. Farbsiebdruck mit Collage (Stoff, Bindfaden und Plan)
b. Siebdruck (s/w) mit Photo
c. Siebdruck (s/w)
d. Siebdruck (s/w) nach einem Photo
Maße: 71 x 56 cm
Auflage: 135 Exemplare (+ XX A. P.)
Papier: Offset
Drucker: Hans-Peter Haas, Stuttgart
Photographen: Thomas Cugini und Frank Donell
Herausgeber: manus presse, Stuttgart

„Ein schweizer Museum, die Kunsthalle Bern, gab Christo zum
ersten Mal die Möglichkeit, ein ganzes Gebäude zu verpacken.
Im Juli 1968 bestand das Museum 50 Jahre lang und feierte
dieses Ereignis mit einer Ausstellung raumbezogener Arbeiten
von 12 internationalen Künstlern. Als einer der 12 Teilnehmer
stellte Christo nichts im Museum aus, sondern verpackte buch-
stäblich die ganze Ausstellung. „Ich nahm die Environments der
11 anderen Künstler" sagte er belustigt, „und verpackte sie. Ich
hatte mein ganzes Environment innen." Christo verhüllte die
Kunsthalle mit 2500 qm verstärkter Plastikfolie, die von der
abgelegten ersten Hülle des Kasseler Luft-Pakets übrig geblieben
war, befestigte sie mit 3000 m Nylonseil und ließ am Eingang
eine Öffnung, damit die Besucher das Gebäude betreten konnten.
Die Kunsthalle ist, trotz ihrer runden Wände und des schrägen
Daches, ein massiges Bauwerk; die transparente Umhüllung
verlieh der klobigen Silhouette aber erheblich weichere Formen.
Dach und Gesims waren die einzigen architektonischen Elemen-
te, deren Konturen in aller Schärfe und Klarheit sichtbar blieben.
Die üppige Plastik-Verschleierung des Gebäudes wurde von
weichen wogenden Faltungen und einem stetig wechselnden
Muster schimmernder Reflexe belebt.
Die Verpackungsarbeiten – von 11 Bauarbeitern durchgeführt –
dauerten sechs Tage lang." (David Bourdon in „Christo",
© 1970 Harry N. Abrams, Inc., Publishers, New York)

27. Wrapped Kunsthalle Bern

1972
Box (designed by Christo) with 4 prints:
a. Color Screenprint with collage of fabric, twine and plan
b. Screenprint with collaged photograph
c. Screenprint (b/w)
d. Screenprint (b/w) from photograph
Size: 71 x 56 cm
Edition: 135 copies and XX artist's proofs
Paper: Offset paper
Printer: Hans-Peter Haas, Stuttgart
Photographers: Thomas Cugini and Frank Donell
Publisher: manus presse, Stuttgart

"A Swiss art museum, the Kunsthalle Bern, gave Christo his first
opportunity to fully package an entire building. July 1968,
marked the fiftieth anniversary of the museum, and the event
was celebrated with an international group show of environmen-
tal works by twelve artists. As one of the dozen participants,
Christo showed nothing inside the museum, but literally packaged
the entire show. "I took the environments by eleven other
artists", he remarked with amusement, "and packaged them.
I had my whole environment inside". Christo shrouded the
Kunsthalle with 27,000 square feet of reinforced polyethylene,
which was left-over from the discarded first skin of the Kassel
air package, secured it with 10,000 feet of nylon rope, and
made a slit in front of the main entrance so visitors could enter
the building. The Kunsthalle is a bulky-looking building, despite
its curved walls and sloping roof, but its silhouette was consider-
ably softened by the mantle of translucent polyethylene. The
only architectural elements that remained visible with any
sharpness and clarity were contours of the roof and cornices.
The sides of the building were luxuriously swagged and the
plastic veiling was continually animated by soft, billowing folds
and an always-changing pattern of glimmering highlights.
The wrapping process took six days with the help of eleven
construction workers." (David Bourdon in "Christo", © 1970
Harry N. Abrams, Inc., Publishers, New York)

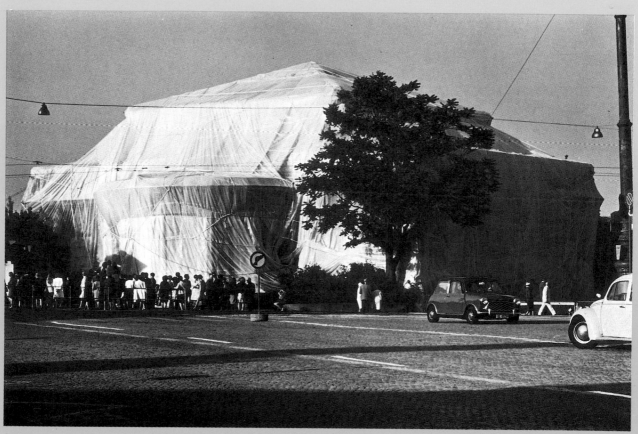

d

28. Doppel-Schaufenster

1972
Doppel-Objekt aus Aluminium und Plexiglas
a. grün bemalt
b. weiß bemalt
c. mit braunem Packpapier verklebt
Maße: zweiteilig, je 90,5 x 60,5 cm
Auflage: a) 20 Exemplare, b) 30 Exemplare, c) 15 Exemplare
handbemalt bzw. collagiert von Christo
Herausgeber: Tanglewood Press, New York

Die Objekte wurden produziert, um durch den Verkauf Geld für
das Running Fence Projekt zu beschaffen.
Siehe Nr. 5, 6, 52, 59, 60

28. Double Show Window

1972
Two plexiglass and aluminum objects with
a. green paint on plexiglass
b. white paint on plexiglass
c. brown wrapping paper taped on plexiglass
Size: Two parts, each 90.5 x 60.5 cm
Edition: a) 20 copies, b) 30 copies, c) 15 copies
handpainted or handcollaged by Christo
Publisher: Tanglewood Press, New York

Published to raise money for the Running Fence Project.
The object refers to the „Store Front" subject, see Nos. 5, 6, 52, 59, 60

a

b

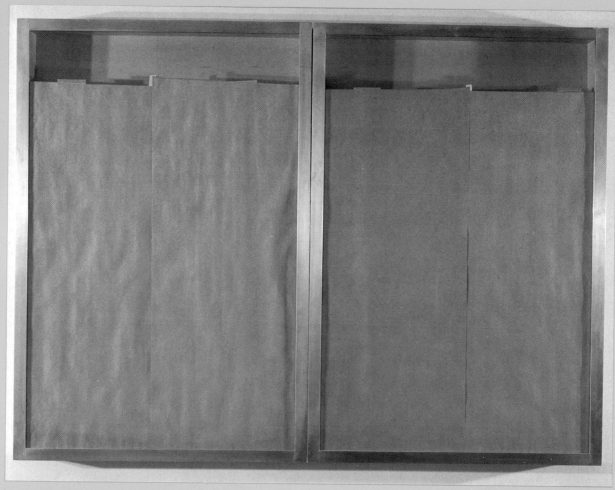

c

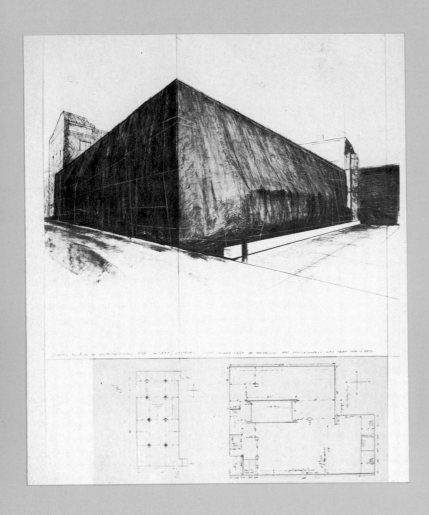

29. Verpackung des Museum of Contemporary Art, Chicago

1972
Farblithographie, 107 x 81,3 cm
Auflage: 60 Exemplare (+ 10 A. P. + 10 S. P.)
Papier: Arjomari Karton
Drucker und Herausgeber: Landfall Press, Chicago

Publiziert zur Finanzierung des Valley Curtain Projekts.

Christo verpackte das Museum im Winter 1969 mit einer
3000 m langen Plane und 1250 m Seil. Während das Museum
(45 Tage lang) verpackt war, lief im Inneren die Ausstellung:
„850 qm verpackter Fußboden".

29. The Museum of Contemporary Art, Chicago, Wrapped

1972
Color lithograph, 107 x 81.3 cm
Edition: 60 copies and 10 artist's proof and 10 subscriber's proofs
Paper: Arjomari
Printer and Publisher: Landfall Press, Chicago

Published to help finance the Valley Curtain Project.

The wrapping of the museum took place during the winter of
1969. The building was wrapped in 10,000 feet of heavy dark
tarpaulin and 3,600 feet of rope, for 45 days. While the museum
was wrapped, Christo had an exhibition inside: "Wrapped Floor —
2,800 sq.ft.".

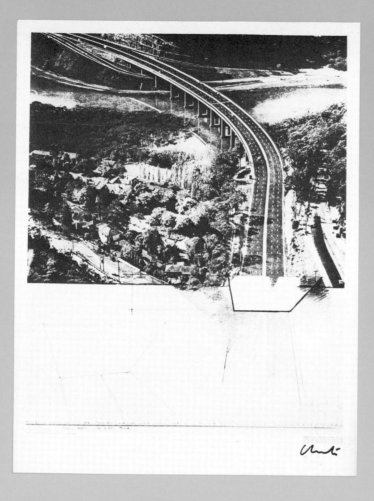

30. Gesperrte Autobahn, Projekt

1972
Offset (s/w), 87,5 x 61 cm
Auflage: 200 Exemplare (+ 25 A. P.)
Papier: Offset
Drucker: Lithographers of America
Herausgeber: Local One, Amalgamated

Projekt für 500 Meilen 6-spuriger Autobahn quer durch die
Vereinigten Staaten (Ost-West): alle Einfahrten werden durch ein
90 cm dickes und 11 bis 15 m hohes Glas gesperrt.

Das Blatt war – neben Blättern anderer amerikanischer Künstler
– Teil einer Kampagne zur Unterstützung der Massentransport-
mittel. Es wurde von „Experiment in Art und Technology Inc." in
Auftrag gegeben.

30. Closed Highway, Project

1972
Offset print (b/w), 87.5 x 61 cm
Edition: 200 copies and 25 artist's proofs
Paper: Offset paper
Printer: Lithographers of America
Publisher: Local One, Amalgamated

Project for 500 miles 6 lanes east-west highway across the USA.
All entrances will be closed with a 36 to 48 feet high glass wall,
36 inches thick.

The print was part of a campaign to promote mass transportation.
It was – together with prints by other American artists –
commissioned by Experiment in Art and Technology Inc.

31. Spoleto 1968 – Verpackter Brunnen
und verpackter Turm

1972
Mappe mit 5 Graphikblättern
a. Serigraphie (Stadtplan)
b. Farbserigraphie, collagiert mit Stoff und Bindfaden
c. Serigraphie (s/w) von Photo
d. Farbserigraphie
e. Serigraphie (s/w) von Photo
Maße: 82,5 x 65 cm
Auflage: 100 Exemplare (+ 14 A. P.)
Papier: Fabriano Bütten; b.) auf Karton aufgezogen
Drucker: Multicenter Grafica, Mailand
Herausgeber: Edizioni Multicenter, Mailand

„1968 wollte Christo – anläßlich des „Festival of Two Worlds" –
das Opernhaus von Spoleto, das Teatro Nuovo aus dem 18.
Jahrhundert, verpacken, das eines der wichtigsten Sehenswür-
digkeiten dieser kleinen Bergstadt in Mittelitalien ist. Jedoch
Christo erhielt, wie so oft, nicht die erforderliche Genehmigung,
diesmal aus feuerpolizeilichen Gründen. Statt des Opernhauses
bat man ihn, einen mittelalterlichen Turm am Rande der Stadt
und einen barocken Brunnen im Stadtzentrum zu verpacken.
Beide Gebäude wurden nach seinen Plänen verpackt, während
Christo selbst in Deutschland am „Kasseler Luftpaket" arbeitete.
Der eckige Turm, der wie ein verhüllter Wachposten am Ende
eines mittelalterlichen Walles stand, war einer der ersten Mark-
steine auf dem Weg nach Spoleto, zugleich geheimnisvoller
Hinweis auf die merkwürdige Mischung alter und neuer Kulturen
auf dem Festival of Two Worlds. Auf einem Platz im Zentrum der
Stadt erzeugte der verpackte Brunnen mit dem weißen Plastik-
gewebe, das die ganze Fassade des vierstöckigen Gebäudes
bedeckte, einen festlichen Klang und verlieh dem Bauwerk die
Silhouette einer barocken Kirche. Das weiße Plastikgewebe
schimmerte im Sommerlicht wie weißer Satin und begann
schon bei der leichtesten Brise zu zittern und zu beben. Beide
Verpackungen blieben während der ganzen dreiwöchigen Dauer
des Festivals bestehen..." (David Bourdon in „Christo", © 1970
Harry N. Abrams, Inc., Publishers, New York)
Die Projekte wurden von Christo selbst finanziert.

31. Spoleto 1968 – project for:
Wrapped Fountain and Wrapped Tower

1972
Box with 5 prints:
a. Screenprint
b. Color screenprint and collage of fabric and twine
c. Screenprint from b/w photograph
d. Color screenprint
e. Screenprint from b/w photograph
Size: 82.5 x 65 cm

Edition: 100 copies and 14 artist's proofs
Paper: Fabriano; b) mounted on cardboard
Printer: Multicenter Grafica, Milan
Publisher: Edizioni Multicenter, Milan

"In 1968, in conjunction with the Festival of Two Worlds, Christo
almost wrapped the Spoleto opera house, the three-story-high
Teatro Nuovo, an eighteenth-century building that is one of the
principal attractions of the small mountaintop town in central
Italy. Again, Christo was prevented from wrapping the building,
this time by fire laws. In place of the opera house, he was
invited to package a medieval tower on the perimeter of town,
and a baroque fountain in the center of town, which were
wrapped according to his plans while the artist himself was in
Germany at work on the Kassel air package. The square tower,
standing like a shrouded sentinel at one end of a medieval
causeway, was one of the first landmarks on the road winding
into Spoleto, providing an eerie indication of the curious blend
of old and new cultures at the Festival of Two Worlds. In a
piazza in the center of town, the packaged fountain struck a
festive note, with the white plastic fabric, a woven polypropylene,
extending over the entire side of a four-story building, the
silhouette of which resembled a baroque church facade. The
plastic fabric shimmered like white satin in the sunlight and
became tremulous in the slightest whisper of a breeze.
Both packages remained up for three weeks, the duration of the
festival..." (David Bourdon in "Christo", © 1970 Harry N.
Abrams, Inc., Publishers, New York).
The projects were financed by Christo.

a

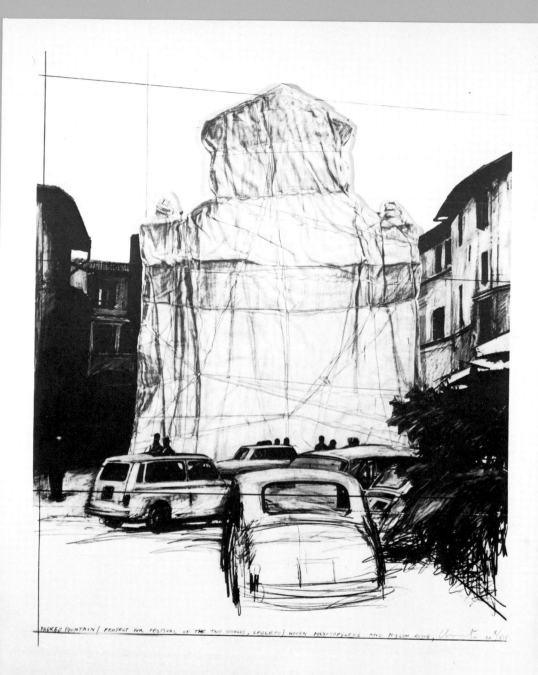

PACKED FOUNTAIN (PROJECT FOR FESTIVAL OF THE TWO WORLDS, SPOLETO) WOVEN POLYPROPYLENE AND NYLON ROPE, *Christo*

b

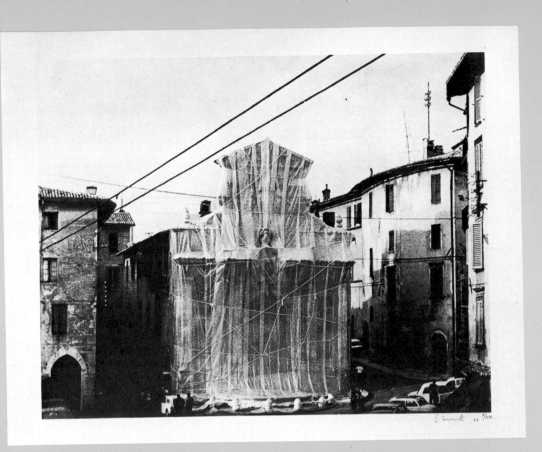

C

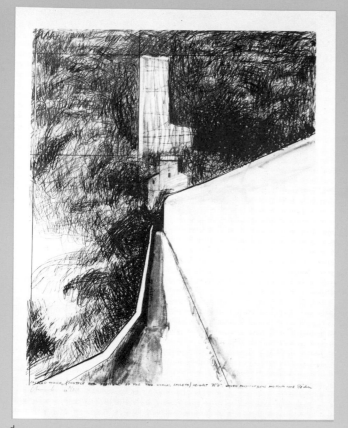

d

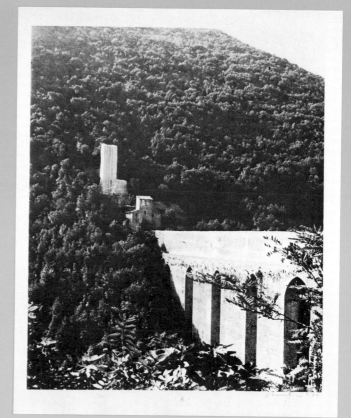

e

32. Mauer aus 10 Millionen Ölfässern, Projekt für den Suezkanal

1972
Mappe mit 5 Blättern + Text:
a. Farbsiebdruck einer Landkarte
b. Siebdruck (s/w) eines Photos von 1905
c. Farbsiebdruck
d. Farbsiebdruck
e. Farbsiebdruck mit collagierter Landkarte
f. Text von Werner Spies
Maße: 71 x 56 cm
Auflage: 70 Exemplare (+ 5 A. P.)
Papier: Bristol-Karton
Drucker: Hans-Peter Haas, Stuttgart
Photograph: H. Roger Viollet und Bethlem Archives
Herausgeber: Fischer Fine Art, London

Die Idee zu dem Projekt entstand 1967 im Zusammenhang mit dem ägyptisch-israelischen Krieg um den Suez-Kanal: Eine Mauer aus schwimmenden Ölfässern sperrt den Kanal. Das Projekt stellt eine Gigantisierung der Idee dar, die zum ersten Mal in Paris 1962 in der Rue Visconti realisiert wurde, als Christo diese Straße mit einer Wand von Ölfässern absperrte, barrikadierte (s. Nr. 12 b). Ebenso wie bei „Gesperrte Autobahn" (Nr. 30) und den „Ladenfenstern" geht es um das Problem der vertikalen Absperrung oder Blockade.

32. Ten Million Oil Drums Wall, Project for the Suez Canal

1972
Box with 5 prints + text:
a. Color screenprint of a map
b. Screenprint (b/w) from a 1905 photograph
c. Color screenprint
d. Color screenprint
e. Color screenprint with collaged map
f. Text by Werner Spies
Size: 71 x 56 cm
Edition: 70 copies and 5 artist's proofs
Paper: Bristol
Printer: Hans-Peter Haas, Stuttgart
Photographer: H. Roger Viollet and Bethlem Archives
Publisher: Fischer Fine Art, London

The project dates back to 1967, and is based on the Egypt-Israel fight over the Suez Canal. A wall of oil drums is floating on the canal, closing it. The project represents a magnification of the idea first realized in Rue Visconti, Paris: the street was closed with a wall of oil drums, in June 1962. (See No. 12 b). The project deals with the idea of vertical barricades like "Closed Highway" (No. 30) and the Store Front pieces.

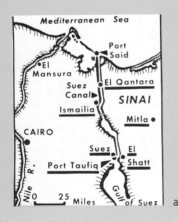

a

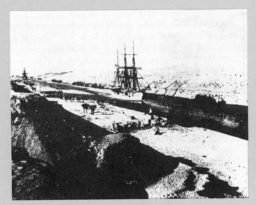

b

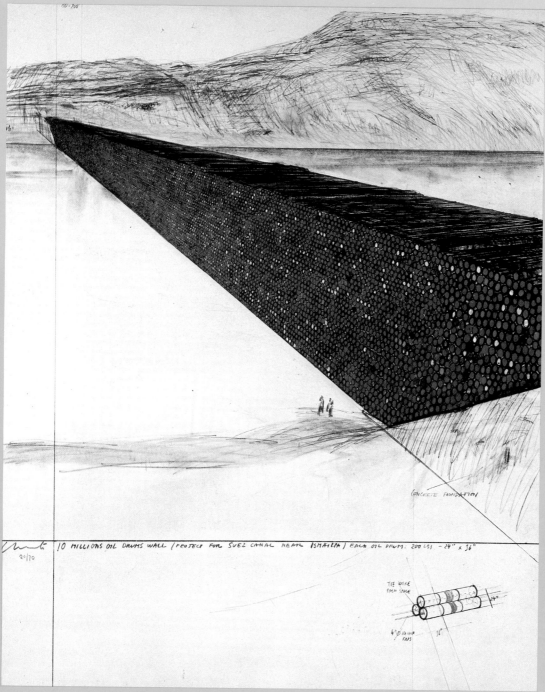

10 MILLIONS OIL DRUMS WALL (PROJECT FOR SUEZ CANAL NEAR ISMAILIA) EACH OIL DRUM: 200 LBS — 24" x 36"

CONCRETE FOUNDATION

TIE WIRE
EACH SPACE

24"

4" D WATER
RODS 36"

C

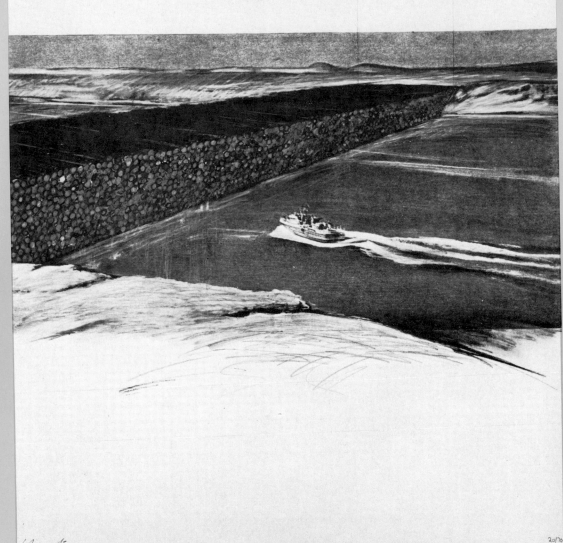

20/70

10 MILLIONS OIL DRUMS WALL (PROJECT FOR SUEZ CANAL, NEAR ISMAILIA) EACH OIL DRUM: 200 LBS - 24"x 36"

d

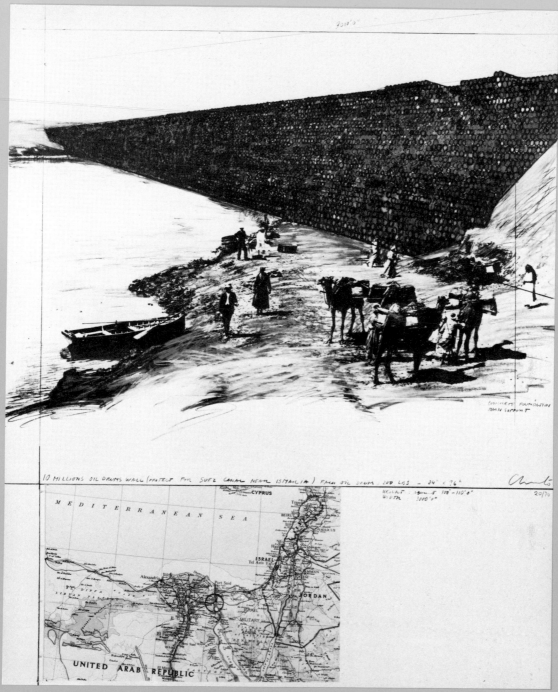

10 MILLIONS OIL DRUMS WALL (PROJECT FOR SUEZ CANAL NEAR ISMAILIA) EACH OIL DRUM 200 LBS - 24" x 36" *Christo*

HEIGHT : approx. 108' - 110'0" 20/70
WIDTH 3000'0"

e

33. Verpackung der „Sylvette" – Projekt für die Washington Square Hochhäuser, New York

1972
A. Lichtdruck und Siebdruck, collagiert mit braunem Packpapier und Photo
B. Lichtdruck und Siebdruck, collagiert mit Photos
Maße: je 64,5 x 50 cm
Auflagen: A: 90 Exemplare + XXX römisch numerierte (+ 40 E. A.);
B: 300 Exemplare
Papier: Fabriano-Bütten
Drucker: Domberger KG, Bonladen
Photograph: Shunk-Kender
Herausgeber: Propyläen-Verlag, Berlin

Die Graphik A erschien in dem Mappenwerk „Hommage à Picasso", zusammen mit Arbeiten von über 50 internationalen Künstlern. Das Blatt zeigt die Beton-Skulptur „Sylvette" von Pablo Picasso, die in New York am Washington Square Village zwischen zwei Appartment-Hochhäusern, entworfen von I. M. Pei, steht.

33. Wrapped Sylvette – Project for the Washington Square Towers, New York

1972
A. Collotype and screenprint, collaged with map and brown wrapping paper
B. Collotype and screenprint, collaged with 2 photographs
Size: je 64.5 x 50 cm
Edition: A: 90 copies and XXX Roman numerals
and 40 artist's proofs; B: 300 copies
Paper: Fabriano
Printer: Domberger KG, Bonladen
Photographer: Shunk-Kender
Publisher: Propyläen-Verlag, Berlin

Print A was part of the portfolio "Hommage à Picasso", with works by approx. 50 international artists. The image is based on the cement sculpture "Sylvette" by Pablo Picasso, placed between two apartment buildings designed by I. M. Pei, at Washington Square Village in Manhattan.

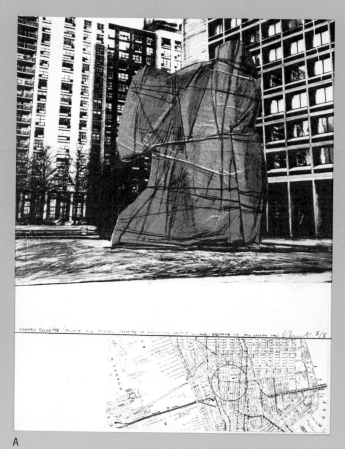

A

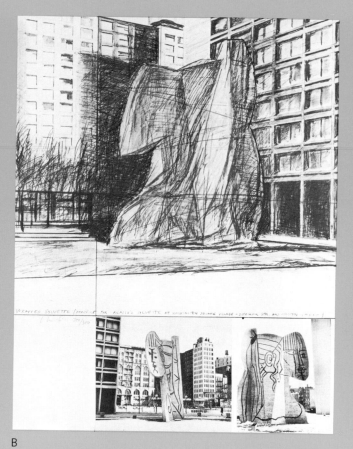

B

34. Verpacktes Hochhaus in Manhatten,
Exchange Place 20, Projekt für New York

1973
Farbsiebdruck, 70,5 x 55,5 cm
Auflage: 100 Exemplare (+ 10 A. P.)
Papier: 400 g Karton
Drucker: Hans-Peter Haas, Stuttgart
Herausgeber: Abrams Original Editions, New York

Publiziert zur Finanzierung des Buches „Valley Curtain", erschie-
nen bei Hatje, Stuttgart; Abrams, New York; Horay, Paris; Prearo,
Mailand.

Das Blatt zeigt einen Ausschnitt aus der Collage „Zwei verpackte
Gebäude von Manhattan, Broadway 2 und Exchange Place 20,
New York", 1964, die Christo kurz nach seiner Ankunft in New
York machte. (siehe auch Nr. 12c und 61)

34. Lower Manhattan Packed Building –
20, Exchange Place, Project for New York

1973
Color screenprint, 70.5 x 55.5 cm
Edition: 100 copies and 10 artist's proofs
Paper: 400 g cardboard
Printer: Hans-Peter Haas, Stuttgart
Publisher: Abrams Original Editions, New York

Made to help fund the book "Valley Curtain",
co-published by Hatje, Stuttgart; Abrams, New York; Horay,
Paris; Prearo, Milan.

The image is a part of the collage "Two Lower Manhattan
Wrapped Buildings, Number 2 Broadway and Number 20
Exchange Place, project for New York" made in 1964, shortly
after Christo arrived in New York. (See Nos. 12c and 61)

35. Verpacktes Heu – Projekt für das Institute of
Contemporary Art in Philadelphia

1973
Farbsiebdruck, 56 x 76 cm
Auflage: 200 Exemplare
Papier: Brauner Pappkarton
Drucker: Hans-Peter Haas, Stuttgart
Herausgeber: Kestner-Gesellschaft, Hannover

1968 machte Christo das Objekt „Verpacktes Heu"
(Größe: 2,40 x 3,70 x 6,10 m) als Teil seiner Ausstellung im
Institute of Contemporary Art in Philadelphia; eine ähnliche
Arbeit („Verpackte Strohballen") entstand 1969 in der Central
Gallery in Sydney.

35. Packed Hay – Project for the Institute of
Contemporary Art, Philadelphia

1973
Color screenprint, 56 x 76 cm
Edition: 200 copies
Paper: Brown cardboard
Printer: Hans-Peter Haas, Stuttgart
Publisher: Kestner-Gesellschaft, Hannover

In 1968 Christo did "Packed Hay", 2.40 x 3.70 x 6.10 meters, as
part of his exhibition at the Philadelphia Institute of Contemporary
Art and in 1969 he did a similar work, "Packed Straw Bales" in
the Central Gallery, Sydney.

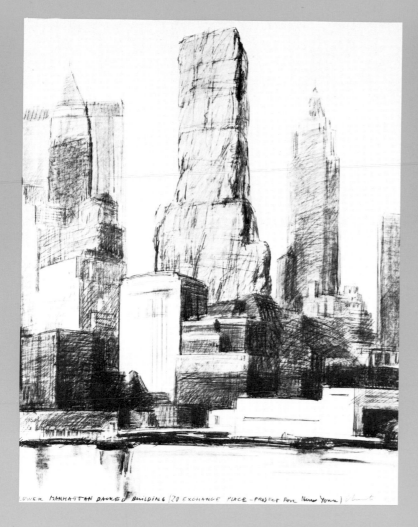

LOWER MANHATTAN PACKED BUILDING (20 EXCHANGE PLACE - PROJECT FOR NEW YORK) Christo

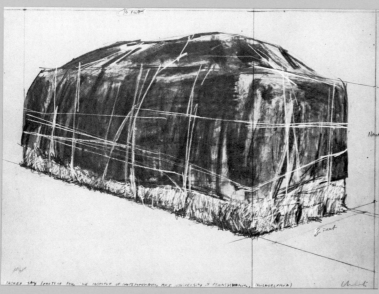

PACKED HAY (PROJECT FOR THE INSTITUTE OF CONTEMPORARY ART UNIVERSITY OF PENNSYLVANIA, PHILADELPHIA)

36. Eingepackte Frau – Projekt für das Institute of Contemporary Art in Philadelphia

1973
Farbsiebdruck, 71 x 56 cm
Auflage: 120 Exemplare (+ 25 A. P.)
Papier: Karton
Drucker: Hans-Peter Haas, Stuttgart
Herausgeber: Verlag Gerd Hatje, Stuttgart

Das Blatt wurde zur Finanzierung des Buches „Christo – Valley Curtain" herausgegeben.

Die erste Verpackung einer Frau fand 1962 in Paris statt; ähnliche Aktionen machte Christo im gleichen Jahr in Düsseldorf, 1963 in London, 1967 in Minneapolis. 1968 verpackte Christo sieben junge Frauen während der Eröffnung seiner Ausstellung im Institute of Contemporary Art an der Universität von Pennsylvania in Plastikfolie ein. Sie wurden auf Podeste gelegt und blieben 5 Stunden lang eingepackt.

36. Wrapped Woman – Project for the Institute of Contemporary Art, Philadelphia

1973
Color screenprint, 71 x 56 cm
Edition: 120 copies and 25 artist's proofs
Paper: Cardboard
Printer: Hans-Peter Haas, Stuttgart
Publisher: Verlag Gerd Hatje, Stuttgart

The print was made to help in the funding of the publication of the book "Christo – Valley Curtain".

The first wrapping of a woman took place in Paris 1962. That same year a similar event took place in Düsseldorf, in 1963 in London and in Minneapolis in 1967. In 1968 seven young women were wrapped in polyethylene and rope for the opening of Christo's exhibition at the Institute of Contemporary Art, University of Pennsylvania. The wrapped women were placed lying on large bases and remained wrapped for 5 hours.

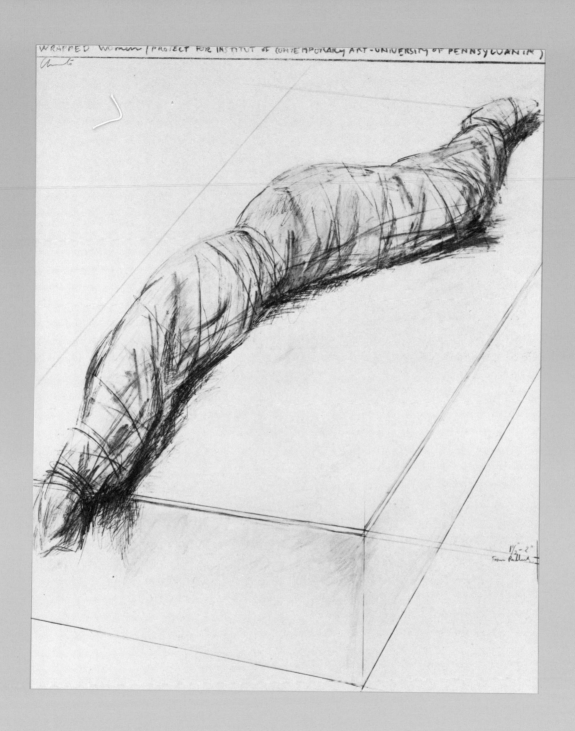

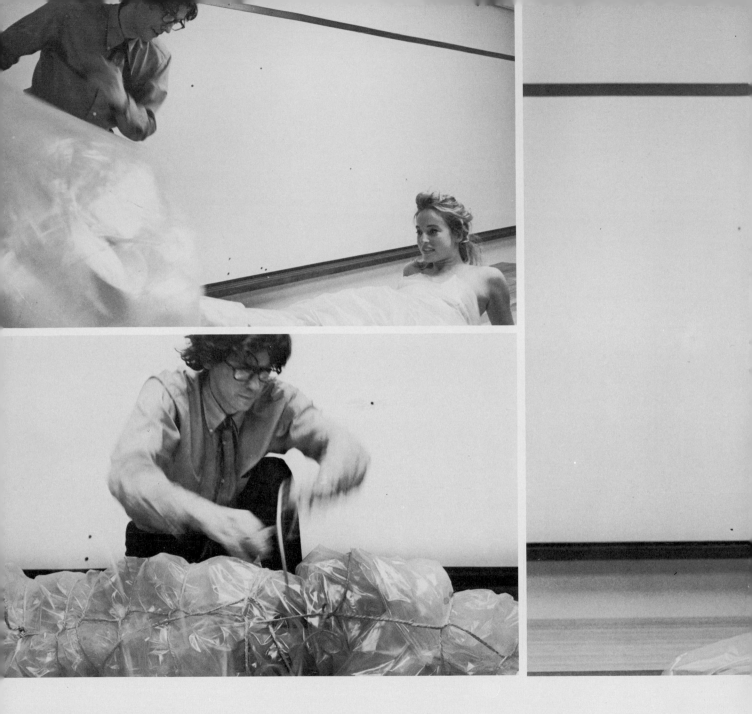

Christo during the wrapping of one of seven young women at the Philadelphia Institute of Contemporary Art, 1968

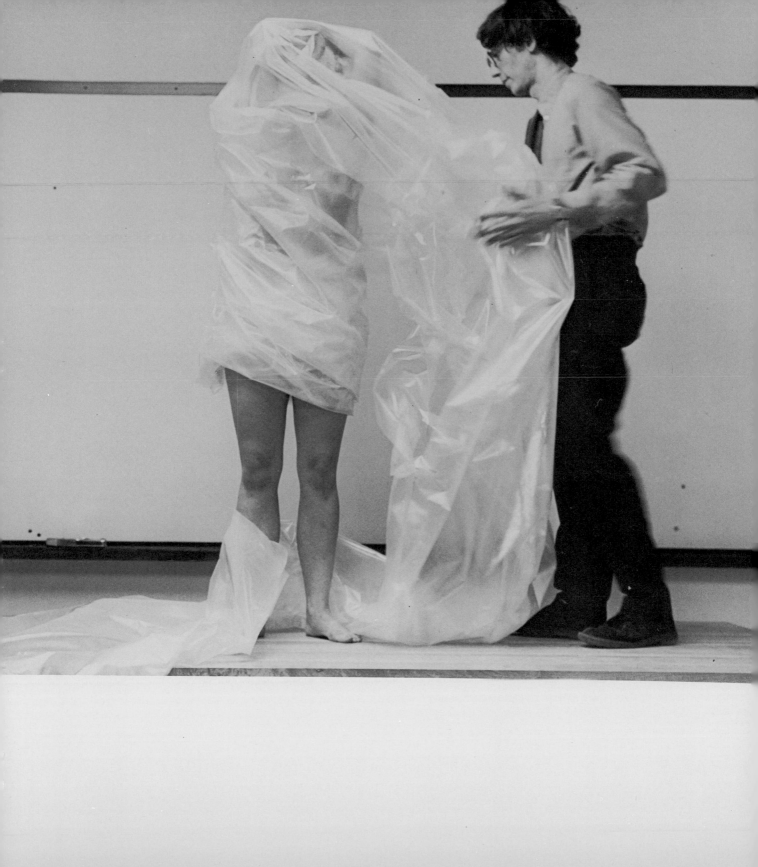

37. Tal-Vorhang – Rifle, Colorado

1973
Vier Farboffset-Blätter (nach Photos), 84 x 59 cm
Auflage: 120 Exemplare (+ 30 A. P.)
Papier: Offset
Drucker: Alfred Holle, Düsseldorf
Photograph: Harry Shunk
Herausgeber: Kunsthalle Düsseldorf, Louisiana Kunstmuseum, Dänemark; Henie-Onstad Foundations, Norwegen; La Rotonda, Mailand

Die vier Blätter wurden anläßlich der europäischen Ausstellung der Dokumentation des Valley Curtain Projekts herausgegeben; die gleichen Motive wurden auch als Plakate für die Ausstellungen gedruckt.

Christo begannn 1970, an dem Valley Curtain Projekt zu arbeiten; es wurde am 10. August 1972 in der Rifle-Schlucht in Colorado fertiggestellt. Der Tal-Vorhang bestand aus 2000 qm transparenten Nylongewebes (orange), 50 Tonnen Stahlseile und 800 Tonnen Beton für die Fundamente. Er war 417 m breit, an den Seiten 111 m und in der Mitte 55 m hoch. Am 11. April, einen Tag nach seiner Fertigstellung, erzwang ein heftiger Sturm den Abbau des Vorhangs.

37. Valley Curtain – Rifle Gap, Colorado

1973
Four color offsetprints, 84 x 59 cm
Edition: 120 copies and 30 artist's proofs
Paper: Offset paper
Printer: Alfred Holle, Düsseldorf
Photographer: Harry Shunk
Publisher: Kunsthalle Düsseldorf; Louisiana Art Museum, Denmark; Henie-Onstad Foundations, Norway; La Rotonda, City of Milan

The series of prints were made for the European tour of the exhibition documenting the Valley Curtain project. The same images were used as posters for the exhibition.

The Valley Curtain project was started in 1970 and was completed on August 10th, 1972 at Rifle Gap, Colorado. The Valley Curtain was made of 200,000 square feet of translucent orange woven nylon polyamide, 110,000 pounds of steel cables and 800 tons of concrete for the foundations. The width of the Curtain was 1,368 feet and the height was 365 feet at each end and 182 feet at the center. On August 11th, 28 hours after completion, a gale made it necessary to start the removal of Valley Curtain.

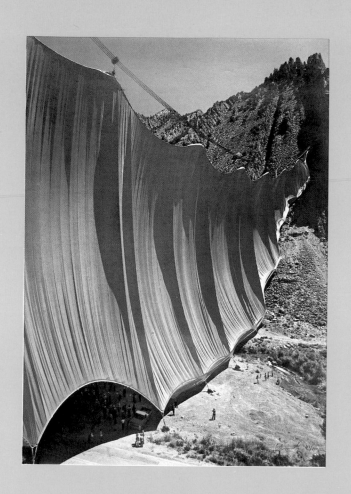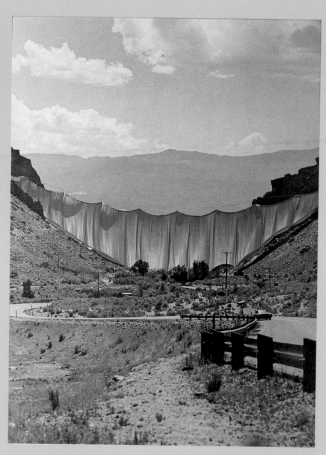

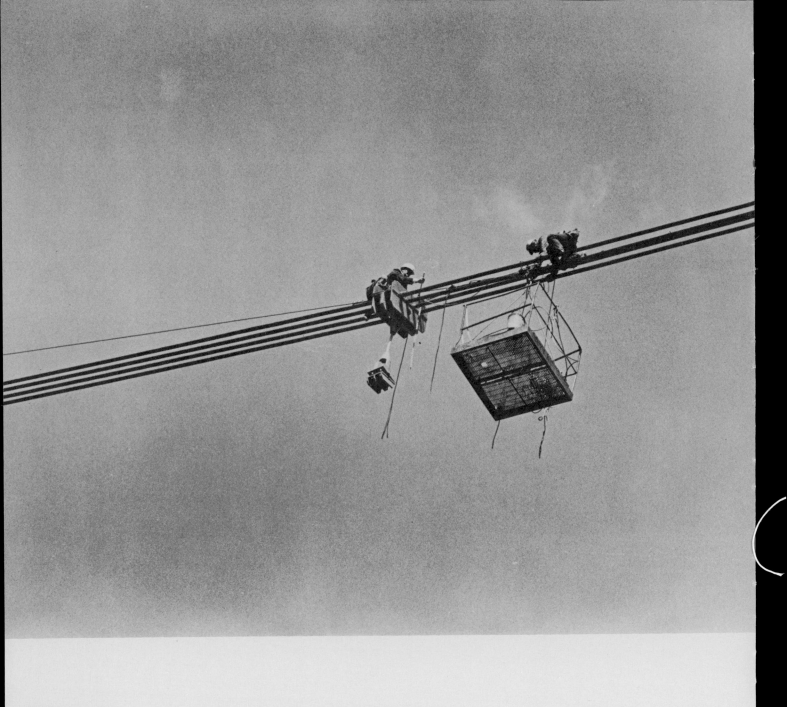

Valley Curtain, 1971/72. Iron workers, 185 feet above the ground, installing one of the eleven cable clamps connections, 600 lbs each

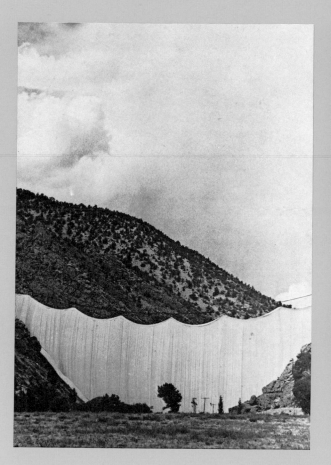
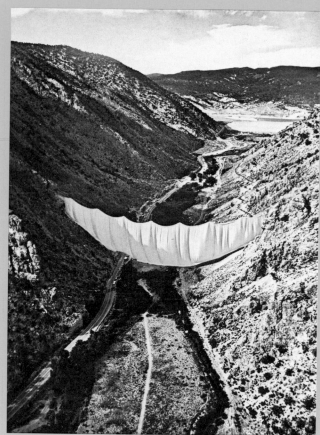

38. Verpacktes Buch

1973
Buch („Christo"), mit Bindfaden in Leinentuch verpackt
Maße: 30.5 x 28.5 x 3.5 cm
Auflage: 100 von Christo handgemachte Exemplare (+ 10 A. P.)
Herausgeber: Abrams Original Editions, New York

Ediert, um zur Finanzierung des Buches „Christo" von David
Bourdon, herausgegeben von Abrams, New York, beizutragen.

38. Wrapped Book

1973
The book "Christo", wrapped in canvas and twine
Size: 30.5 x 28.5 x 3.5 cm
Edition: 100 copies and 10 artist's proofs, handmade by Christo
Publisher: Abrams Original Editions, New York

Published to help fund the publication of the Abrams book
"Christo", by David Bourdon.

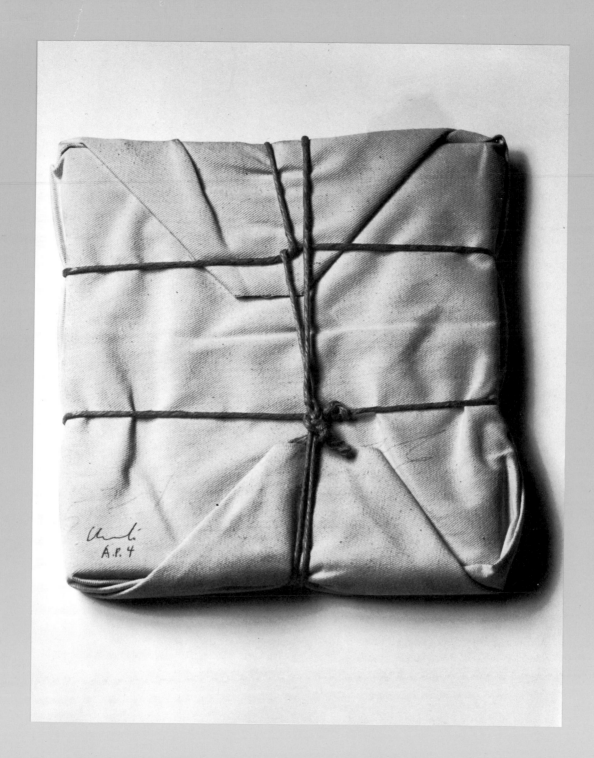

39. Verpackte Venus – Villa Borghese

1974
Lithographie, 65 x 50 cm
Auflage: 200 Exemplare (+ 35 römisch numerierte, + 10 A. P.)
Papier: Arjomari Special
Drucker: Landfall Press, Chicago
Herausgeber: Christo, für den Schweizerischen Kunstverein,
St. Gallen

Christo wurde gebeten, eine Graphikauflage für einen Fonds für
bedürftige Kinder zu stiften. Da er bei Landfall Press gerade an
dem Blatt „Verpackte Venus" arbeitete, ließ er eine Version
davon für den Fonds drucken. Das andere Blatt kam ein Jahr
später heraus (Nr. 40).

39. Wrapped Venus – Villa Borghese

1974
Lithograph, 65 x 50 cm
Edition: 200 copies, 35 Roman numerals and 10 artist's proofs
Paper: Special Arjomari
Printer: Landfall Press, Chicago
Publisher: Christo for Schweizerischer Kunstverein
in St. Gallen

Christo had been asked to donate this edition as charity to help
a foundation for needy children. Since Christo was working on a
"Wrapped Venus" print at Landfall Press, he decided to do a
version of that for the foundation. The other "Wrapped Venus"
was published the following year. (See No. 40).

40. Verpackte Venus – Villa Borghese

1975
Radierung und Farblithographie, collagiert mit Umdruck-Papier
Maße: 71 x 56 cm
Auflage: 50 Exemplare (+ 25 römisch numerierte
+ 12 A. P. + 5 S. P.)
Papier: Twinrocker (handgeschöpft) und Japanpapier
Drucker und Herausgeber: Landfall Press, Chicago

Erschienen in der Mappe „Radierungen aus der Landfall Press"
mit Blättern von insgesamt 6 Künstlern.

Die Verpackung der Venus fand im Dezember 1963 ohne
behördliche Genehmigung im Park der Villa Borghese statt und
blieb 4 Monate lang bestehen. Sie fiel niemandem auf; die Leute
nahmen an, die Statue sei aus konservatorischen Gründen von
der Parkverwaltung verhüllt worden.

40. Wrapped Venus – Villa Borghese

1975
Etching and color lithograph with collaged transfer paper
Size: 71 x 56 cm
Edition: 50 copies, 25 Roman numerals, 12 artist's proofs
and 5 subscriber's proofs
Paper: handmade Twinrocker and Japanese paper
Printer and Publisher: Landfall Press, Chicago

Included in the "Landfall Press Etching Portfolio", with works
also by William Allan, Robert Cottingham, Claes Oldenburg,
Philip Pearlstein and William T. Wiley.

The wrapping of the Venus took place in December 1963,
without permission from the authorities and stayed on for four
months.
Nobody reacted to the statue being wrapped. It was commonly
believed that the wrapping was undertaken by the park authori-
ties for preservation purposes.

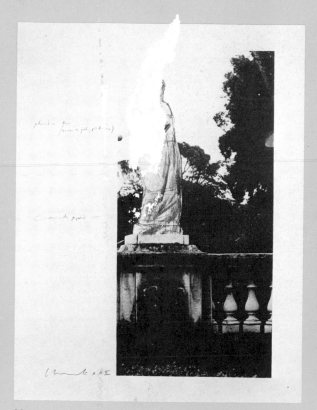

39

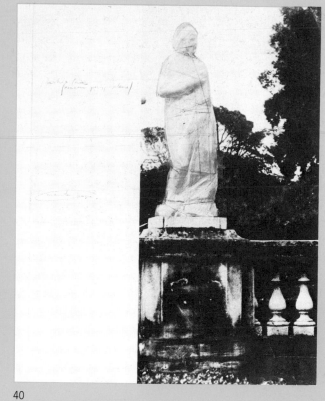

40

41. Verpackte römische Stadtmauer, Porta Pinciana, Rom

1974
Vier Photographien (s/w), 30 x 40 cm
Auflage: 50 Exemplare
Photograph: Massimo Piersanti
Herausgeber: Incontri Internazionali d'Arte, Rom

Die Photos zeigen die Porta Pinciana in Rom, die Christo im Januar 1974 für zwei Monate verpackte. Vier Bogen der 2000 Jahre alten römischen Stadtmauer wurden mit 6820 qm Folie und 3000 m Seil verpackt. Das Projekt war Teil der Ausstellung „Contemporanea" in der Tiefgarage der Villa Borghese. Einer Idee aus dem Jahre 1968 folgend, wollte Christo zunächst die Brücke San Angelo verpacken, die den Vatikan mit der modernen Innenstadt von Rom verbindet, erhielt aber nicht die erforderlichen Genehmigungen. Er beschloß dann, die Stadtmauer zwischen der Via Veneto und der Villa Borghese zu verpacken, die ihn als großstätische Situation im direkten Kontrast zum Park der Villa Borghese interessierte.

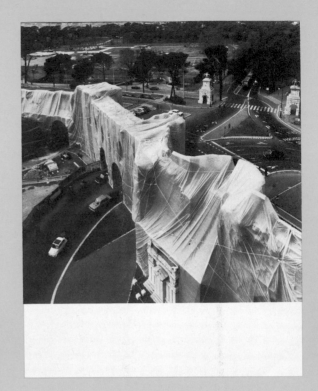

41. Wrapped Roman Wall, Porta Pinciana, Rome

1974
Four black and white photographs
Size: 30 x 40 cm
Edition: 50 copies
Photographer: Massimo Piersanti
Publisher: Incontri Internazionali d'Arte, Rome

The photos show Christo's wrapping of the Porta Pinciana, Rome, January 1974. The wrapping stayed for nearly two months. Four arches of the 2000-year-old Roman Wall were wrapped with 6,820 square meters of woven polypropylene and 3,000 meters of rope. The project was part of the exhibition "Contemporanea", which took place in the underground garage of the Villa Borghese. Following a project that dates back to 1968, Christo originally wanted to wrap the Ponte San Angelo connecting the Vatican with the modern city of Rome, but could not get permission. Christo then chose to wrap the Roman Wall between Via Veneto and Villa Borghese, where there is a very intense urban situation, contrasted by the park of Villa Borghese.

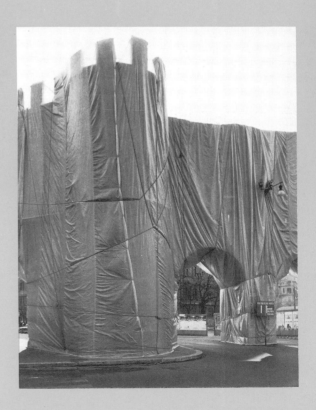

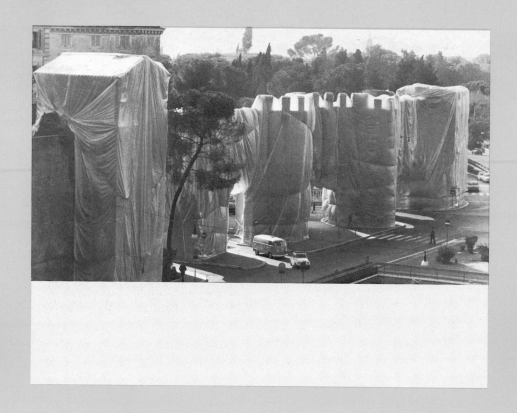

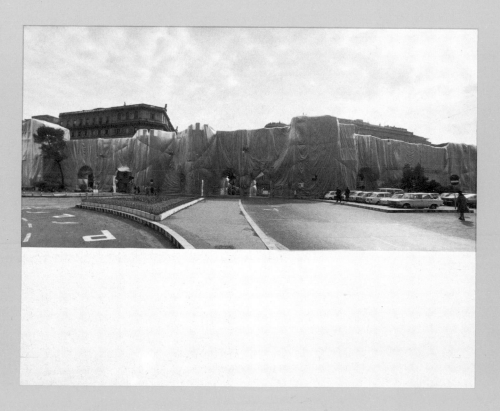

42. Verpackte Küste – Kleine Bucht, Australien

1975
Farblichtdruck, 33 x 40 cm
Auflage: 55 Exemplare (+ 8 römisch numerierte)
Papier: Elfenbein-Karton
Drucker: Schreiber, Stuttgart
Photograph: Harry Shunk
Herausgeber: Edition Schellmann & Klüser, München

Erschienen in der Mappe „Landscapes" mit Blättern von Dibbets, Hamilton und Oppenheim. Das Blatt zeigt einen Ausschnitt aus einem Photo der verpackten Bucht.

„Die Kleine Bucht, Besitz des Prince Henry Krankenhauses, liegt 15 km süd-östlich vom Stadtzentrum von Sydney. Der felsige Küstenabschnitt, der verpackt wurde, ist 2,5 km lang und 50 bis 250 m breit. Die Klippen haben an der nördlichen Seite eine Höhe von 25 m; der Sandstrand an der südlichen Seite liegt auf Meereshöhe.
Für die Verpackung wurden 10000 qm eines synthetischen Gewebes, das für landwirtschaftliche Zwecke hergestellt wird, benutzt. Die Stoffbahnen wurden von 56 km Kunststoff-Seilen (3 cm ∅), die mit 25000 Klammern in den Fels eingeschossen wurden, an den Klippen befestigt.
Die Aufbauarbeit leitete Mr. N. Melville, ein ehemaliger Pionier-Major. 15 Bergsteiger, 110 Arbeiter, Studenten der Universität von Sydney und einer Ingenieurschule, außerdem einige australische Künstler und Lehrer investierten in 4 Wochen insgesamt 17000 Arbeitsstunden in die Verpackung der Bucht. Sie blieb 10 Wochen lang verpackt; danach wurde alles verwendete Material wieder entfernt und der Platz in seinen ursprünglichen Zustand versetzt.
Das Projekt wurde von Christo selbst finanziert."
(aus der Pressemitteilung für das Projekt, 1969)

42. Wrapped Coast – Little Bay, Australia

1975
Color collotype, 33 x 40 cm
Edition: 55 copies and 8 Roman numerals
Paper: Ivory carton
Printer: Schreiber, Stuttgart
Photographer: Harry Shunk
Publisher: Edition Schellmann & Klüser, Munich

Included in a portfolio "Landscapes" with works also by Jan Dibbets, Richard Hamilton and Dennis Oppenheim. The print shows detail from a photograph of the Wrapping at Little Bay.

"Little Bay, property of Prince Henry Hospital, is located 9 miles southeast of the center of Sidney. The cliff-lined shore area that was wrapped was approximately one and a half mile in length, 150 to 800 feet in width, 85 feet in height at the northern part cliffs, and at sea level at the southern part sandy beach.
One million square feet of Erosion Control Mesh (synthetic woven fiber usually manufactured for agricultural purposes), were used for the wrapping. 35 miles of polypropylene rope, 1¼ inch circumference, tied the fabric to the rocks. Ramset guns fired 25,000 charges of fastenings, threaded studs and clips to secure the rope to the rocks.
Mr. N. Melville, a retired Major of the Army Corps of Engineers, was in charge of the construction site. 17,000 manpower hours, over a period of 4 weeks, were executed by: 15 professional mountain climbers, 110 labourers, students from Sydney University and East Sydney Technical College, as well as some Australian artists and teachers. The coast remained wrapped for a period of 10 weeks, then all materials were removed and the site restored to its original condition.
The project was financed by Christo."
(From press release for project, 1969)

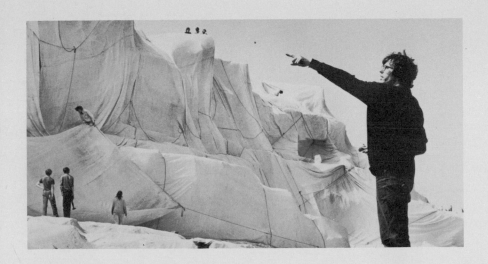

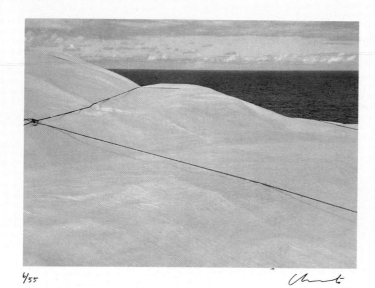

4/55 *[signature]*

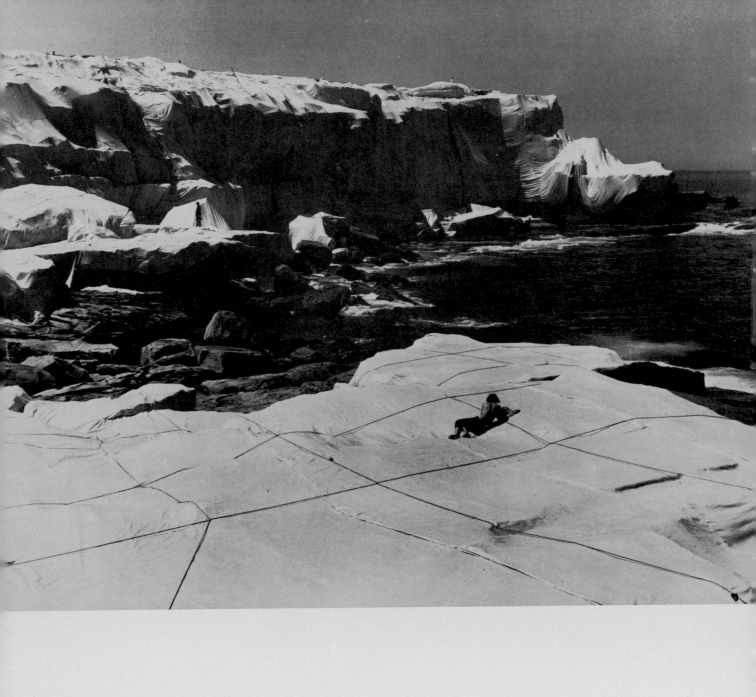

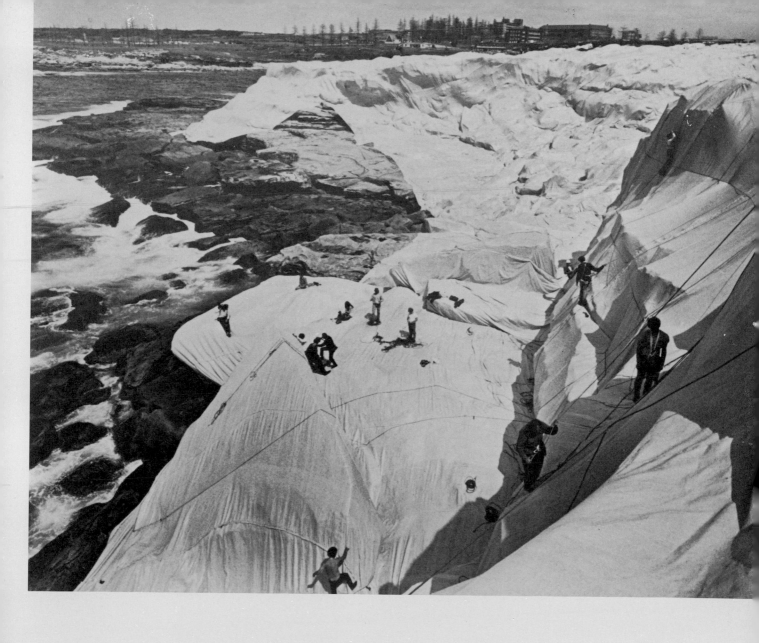

43. Verpacktes Denkmal für Vittorio Emmanuele, Projekt für den Domplatz in Mailand

1975
Mappe mit 5 Blättern, 3 Photos und Text
a., b., c. Drei Photographien (s/w)
d. Farblithographie, collagiert mit Stoff und Bindfaden
e., f. Farblithographien
g. Farblithographie, collagiert mit braunem Packpapier
h. Farblithographie, collagiert mit Stoff und Bindfaden
Maße: 71 x 56 cm
Auflage: 75 Exemplare (+ 10 A. P. + 10 H. C.)
Papier: Guaro auf Karton aufgezogen
Photograph: Ugo Mulas
Drucker: La Poligrafa, Barcelona
Herausgeber: Ediciones Poligrafa, Barcelona

1970 verpackte Christo das Denkmal für den letzten König aus Italien, Vittorio Emmanuele, in Mailand. Als das Monument verpackt war, brach in Mailand ein Streik aus und das verpackte Denkmal diente während der Streikversammlungen auf dem Domplatz als Rednertribüne. Das Denkmal blieb 48 Stunden lang verpackt.

43. Wrapped Monument to Vittorio Emmanuele, Project for Piazza del Duomo, Milan

1975
Box with five prints, three photographs and text
a., b., c. Three b/w photographs
d. Color lithograph with collage of fabric and twine
e., f. Color lithographs
g. Color lithograph with collage of brown wrapping paper
h. Color lithograph with collage of fabric and twine
Size: 71 x 56 cm
Edition: 75 copies, 10 artist's proofs and 10 Hors Commerce
Paper: Guaro mounted on cardboard
Photographer: Ugo Mulas
Printer: La Poligrafa, Barcelona
Publisher: Ediciones Poligrafa, Barcelona

In 1970 Christo wrapped the monument to the last King of Italy, Vittorio Emmanuele, in Milan. After the wrapping was completed, a strike broke out in Milan and the Wrapped Monument was used as stand for speakers during strike meetings in the Piazza del Duomo. The monument stayed wrapped for 48 hours.

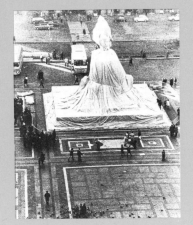

a

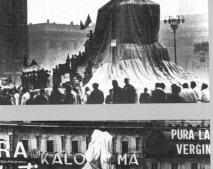

b

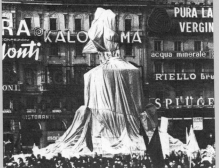

c

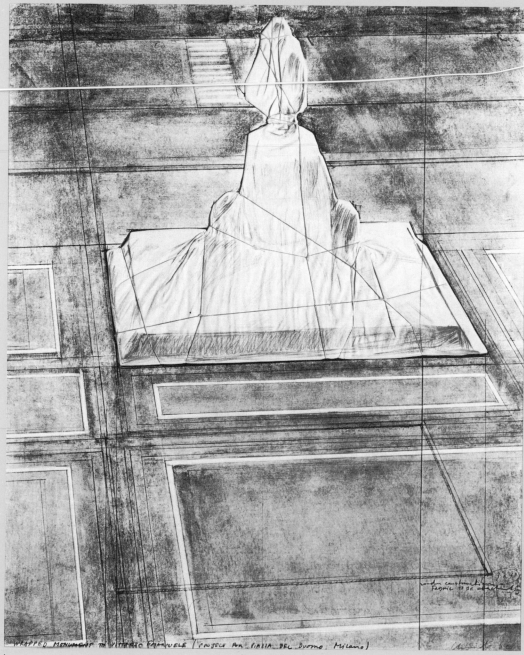

WRAPPED MONUMENT TO VITTORIO EMANUELE (PROJECT FOR PIAZZA DEL DUOMO, MILANO)

h

44. Verpacktes Denkmal für Vittorio Emmanuele

1973
Photographie (s/w), 50 x 50 cm
Auflage: 600 Exemplare
Photograph: Shunk-Kender
Herausgeber: Attilo Codognato, Venedig

Projekt: s. Nr. 43

44. Wrapped Monument to Vittorio Emmanuele

1973
Photograph (b/w), 50 x 50 cm
Edition: 600 copies
Photographer: Shunk-Kender
Publisher: Attilo Codognato, Venice

Project: see No. 43

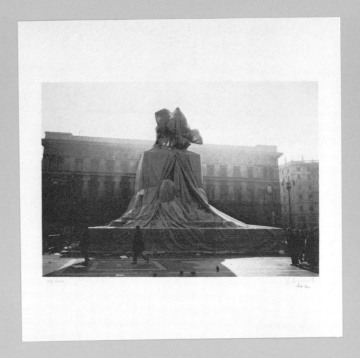

45. Texas Mastaba, Projekt

1976
Farblithographie, Siebdruck und Collage
Maße: 78,5 x 57,5 cm
Auflage: 200 Exemplare (+ 20 A. P. + 20 H. C.)
Papier: Braune Pappe
Drucker: Styria Studio, New York
Herausgeber: APC Editions, Chermayeff
und Geismer Associates, New York

Erschienen in der Mappe „Amerika: Das dritte Jahrhundert" mit
Arbeiten von insgesamt 13 amerikanischen Künstlern. Der
Verkaufserlös der Mappe sollte der Organisation „Care Corpora-
tion" zugute kommen, die von Robert Rauschenberg organisiert
wurde, um Künstlern in wirtschaftlichen Schwierigkeiten zu helfen.

Projekt: s. Nr. 49

45. Texas Mastaba, Project

1976
Color lithograph and screenprint with collage
Size: 78.5 x 57.5 cm
Edition: 200 copies, 20 artist's proofs and 20 Hors Commerce
Paper: Chipboard
Printer: Styria Studio, New York
Publisher: APC Editions, Chermayeff
and Geismer Associates, New York

Included in the portfolio "America: The Third Century", with
works of altogether 13 American Artists, published in com-
memoration of the Bicentennial. The profit of the sale was
dedicated to the organization "Care Corporation" initiated by
Robert Rauschenberg to help artists in financial difficulties.

Project: see No. 49

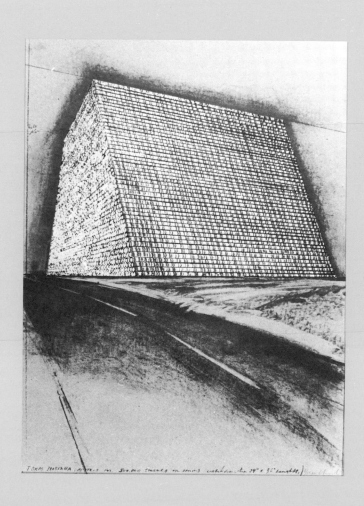

TEXAS MASTABA (PROJECT FOR 500,000 STACKED OIL DRUMS, extended, top 74" x 95" length 88.)

46. Verpackte Brücke, Projekt für Pont Alexandre III, Paris

1977
Farblithographie, collagiert mit Photo
Maße: 71 x 56 cm
Auflage: 99 Exemplare, numeriert 1–33 und 1–66
Papier: 260 g Rives Bütten
Drucker: Matthieu, Zürich
Photograph: Harry Shunk
Herausgeber: Grafos Verlag, Vaduz, Liechtenstein

Christo machte einige Zeichnungen und Collagen „Verpackte Brücke, Projekt für Le Pont Alexandre III, Paris", bevor sich sein Interesse auf den Pont Neuf richtete. Seit 1977 arbeitet er an dem Vorhaben „Der Verpackte Pont Neuf, Projekt für Paris". Nachdem Christo die ersten Vorzeichnungen für den Pont Alexandre III gemacht hatte, wurde ihm klar, daß diese Brücke weder den topographischen und ästhetischen Abwechslungs-reichtum, noch die historische Bedeutung hat, die den Pont Neuf auszeichnet.
Die zeitweilige Verpackung, („Metamorphose") des Pont Neuf wird der Brücke eine neue plastische Dimension verleihen und sie – für einige Tage – in ein Kunstwerk verwandeln: Der glän-zende, sandfarbene Stoff der Verpackung wird so mit Tauen auf die Brücke gespannt werden, daß ihre Grundformen erkennbar bleiben, reliefartige Formen betont und Proportionen und Details zu großen Formen zusammengefaßt werden.

46. Wrapped Bridge, Project for Le Pont Alexandre III, Paris

1977
Color lithograph with photograph
Size: 71 x 56 cm
Edition: 99 copies numbered 1–33 and 1–66
Paper: Rives 260 g
Printer: Matthieu, Zürich
Photographer: Harry Shunk
Publisher: Grafos Verlag, Vaduz, Liechtenstein

Christo made a few drawings and collages for "Wrapped Bridge, Project for Le Pont Alexandre III, Paris", before he set his mind on the Pont Neuf. "The Pont Neuf Wrapped, Project for Paris" is a current project, presently in progress, at which Christo has been working since 1977.
After making some preparatory drawings for the Pont Alexandre III, Christo became aware that this particular bridge, esthetically impressive in itself; mostly because of the Grand Palais and Petit Palais in the background, does not, however, have the topographical and visual variety, nor is it as important historically as compared to what the Pont Neuf has to offer.
The temporary wrapping of the Pont Neuf will continue the tradition of succesive metamorphoses by presenting a new sculptural dimension and will become for a few days, a work of art in itself. Ropes will hold down the shiny sandstone-colored cloth to the Bridge's surface and maintain its principal shapes, accentuating its reliefs while generalizing proportions and de-tails.

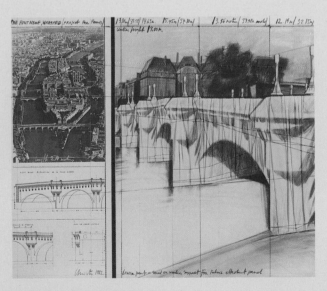

The Pont Neuf Wrapped, project for Paris, 1982
Collage in 2 parts: 71 x 28 cm + 71 x 56 cm
Fabric, twine, pastel, charcoal, pencil, crayon, photostat

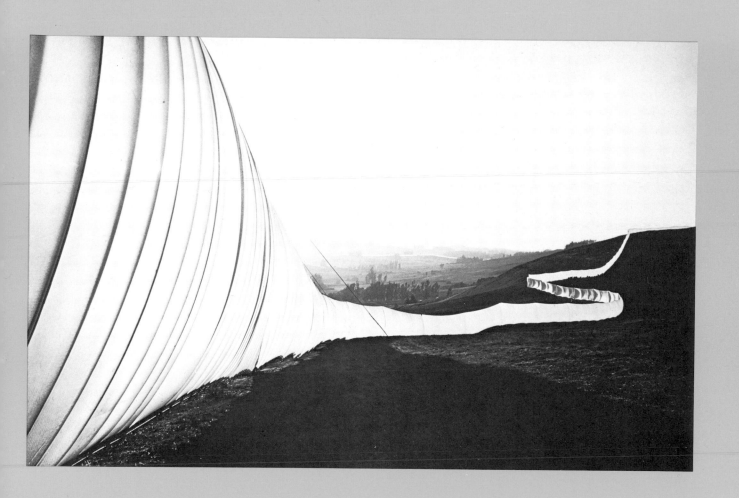

48. Verpackter Sessel, Projekt

1977
Farblithographie, 56 x 71 cm
Auflage: 100 Exemplare (+ 15 A. P.)
Papier: Rives Couronne Bütten
Drucker: Matthieu, Zürich
Herausgeber: Abrams Original Editions, New York

Das Blatt wurde herausgegeben, um die Veröffentlichung des Buches „Christo - Running Fence" bei Abrams zu ermöglichen.

Christo hat seit 1958 verschiedene verpackte Stühle geamcht; der erste verpackte Sessel entstand 1966 für Christo's Ausstellung im Stedelijk van Abbemuseum, Eindhoven.

48. Wrapped Armchair, Project

1977
Color lithograph, 56 x 71 cm
Edition: 100 copies and 15 artist's proofs
Paper: Rives Couronne
Printer: Matthieu, Zürich
Publisher: Abrams Original Editions, New York

The print was published as part of the arrangement for Abrams publishing the book "Christo – Running Fence".

Christo had done some wrapped chairs since 1958, but the first wrapped armchair was made for Christo's exhibition in the Stedelijk van Abbemuseum, Eindhoven, 1966.

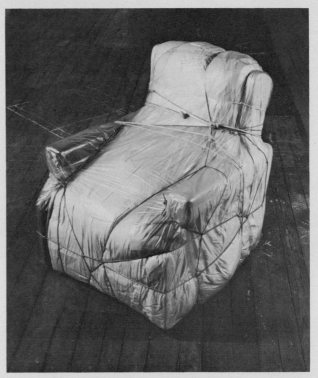

Packed Armchair, 1964–65
Collection Stedelijk van Abbemuseum, Eindhoven

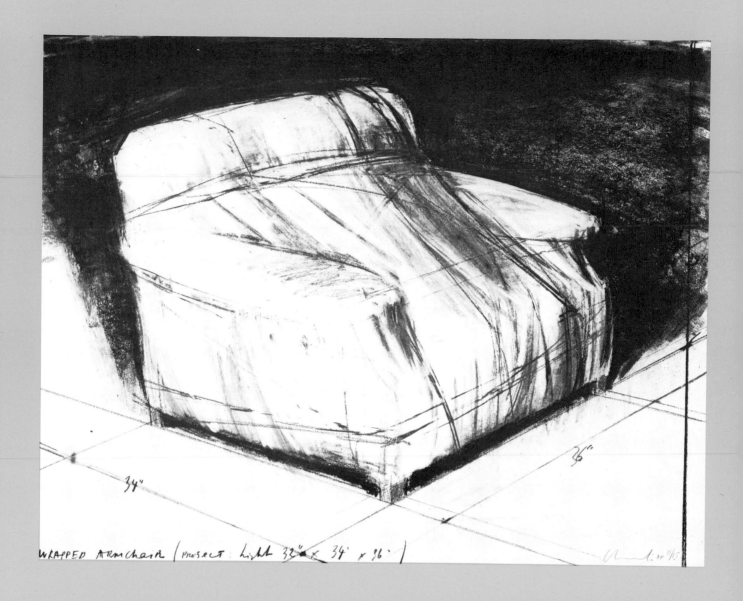

WRAPPED ARMCHAIR (PROJECT: Light 32" x 34' x 36')

49. Texas Mastaba, Projekt

1977
Farbsiebdruck, 70 x 65 cm
Auflage: 110 Exemplare (+ 20 A. P.)
Papier: Karton, weiß
Drucker: Hans-Peter Haas, Stuttgart
Herausgeber: Verlag Gerd Hatje, Stuttgart

Herausgegeben als Finanzierungsbeitrag für das Buch „The Running Fence Project – Christo" von Werner Spies und Wolfgang Volz, verlegt in Koproduktion von: Abrams, New York; Editions du Chêne, Paris; Museum Boymans-van-Beuningen, Rotterdam; Hatje, Stuttgart; Kestner-Gesellschaft, Hannover; Thames and Hudson, London.

Christo benutzte die Mastaba-Form zum ersten Mal 1961 in Köln und realisierte 1968 das erste Mastaba-Projekt (aus 1240 Ölfässern) für das Institute of Contemporary Art in Philadelphia. Eine Mastaba ist eine archaische Bauform, die in Ägypten lange vor den Pyramiden entstand; sie hat zwei schräge und zwei senkrechte Seiten und eine abgeschnittene waagrechte Spitze. „Mastaba" bedeutet im Arabischen Erhöhung und hängt mit Bänken zusammen, die die Araber zur Begrüßung von Gästen vor ihren Häusern errichteten.
Später plante Christo eine große Mastaba in der freien Landschaft in Texas südlich von Houston; das Projekt wurde aber von den Ölgesellschaften, die es finanzieren sollten, nicht unterstützt. Eine kleinere Version schlug Christo für das Rijkmuseum Kröller-Müller vor; sie kam aber ebenfalls nicht zustande. 1978 begann Christo die Arbeit an dem Großprojekt „Mastaba von Abu Dhabi, Projekt für die Vereinigten Arabischen Emirate", das aus 390 500 gestapelten Ölfässern bestehen soll.

49. Texas Mastaba, Project

1977
Color screenprint, 70 x 65 cm
Edition: 110 copies and 20 artist's proofs
Paper: Cardboard
Printer: Hans-Peter Haas, Stuttgart
Publisher: Verlag Gerd Hatje, Stuttgart

Made to help fund the publication of the book "The Running Fence Project – Christo" by Werner Spies and Wolfgang Volz. Co-Publishers: Harry N. Abrams, New York; Editions du Chêne, Paris; Museum Boymans-van-Beuningen, Rotterdam; Verlag Gerd Hatje, Stuttgart; Kestner-Gesellschaft, Hannover; Thames and Hudson, London.

Christo used the Mastaba shape in 1961 in Cologne and the first large-scale Mastaba (1240 oil barrels) was made for the Institute of Contemporary Art, Philadelphia, in 1968. A Mastaba is an archaic shape, used in Egypt long before the pyramids; it has two slanted sides, two parallel vertical sides and a truncated top. In Arabic "Mastaba" means elevation, it refers to the bench built in front of houses and is used to welcome visitors. Later, a project was proposed for a large outdoor Mastaba south of Houston, Texas, this was turned down by the oil companies, which were asked to sponsor the project. A smaller version was proposed for the Rijkmuseum Kröller-Müller, Otterloo, but not accepted. In 1978 Christo started to work at the "Mastaba of Abu Dhabi, Project for the United Arab Emirates", 390,500 stacked oil barrels.

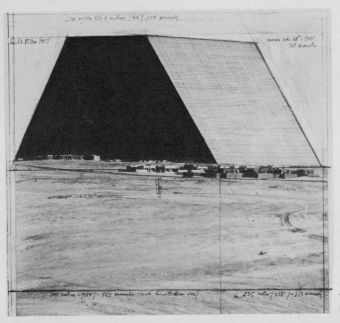

"The Mastaba of Abu Dhabi, project for the Unitad Arab Emirates" Collage 1979, (detail), 80 x 60 cm

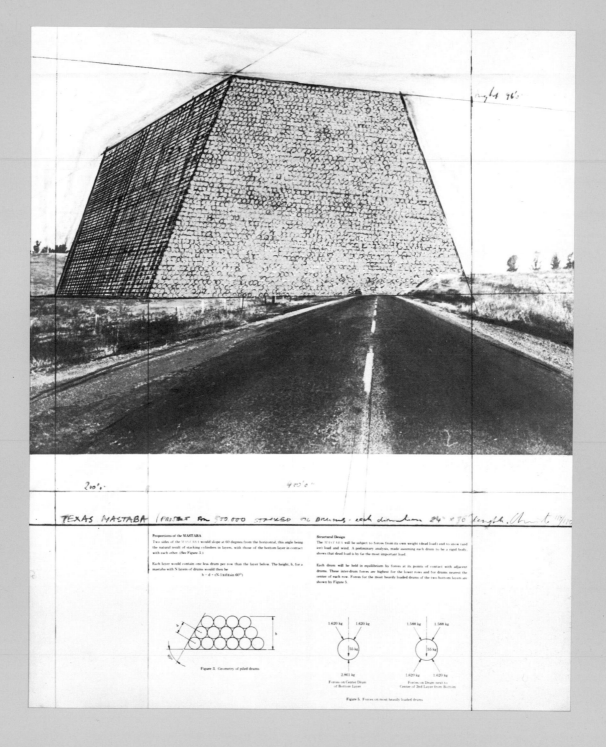

TEXAS MASTABA (PROJECT FOR 500,000 STACKED OIL DRUMS, each diameter 24" x 36" length. Christo 11/)

Proportions of the MASTABA

Two sides of the MASTABA would slope at 60 degrees from the horizontal, this angle being the natural result of stacking cylinders in layers, with those of the bottom layer in contact with each other. (See Figure 3.)

Each layer would contain one less drum per row than the layer below. The height, h, for a mastaba with N layers of drums would then be

$$h = d + (N-1)(d/\sin 60°)$$

Structural Design

The MASTABA will be subject to forces from its own weight (dead load) and to snow (live) load and wind. A preliminary analysis, made assuming each drum to be a rigid body, shows that dead load is by far the most important load.

Each drum will be held in equilibrium by forces at its points of contact with adjacent drums. These inter-drum forces are highest for the lower rows and for drums nearest the center of each row. Forces for the most heavily loaded drums of the two bottom layers are shown by Figure 5.

Figure 3. Geometry of piled drums.

1.620 kg 1.620 kg

55 kg

2.861 kg

Forces on Center Drum
of Bottom Layer

1.588 kg 1.588 kg

55 kg

1.620 kg 1.620 kg

Forces on Drum next to
Center of 2nd Layer from Bottom

Figure 5. Forces on most heavily loaded drums.

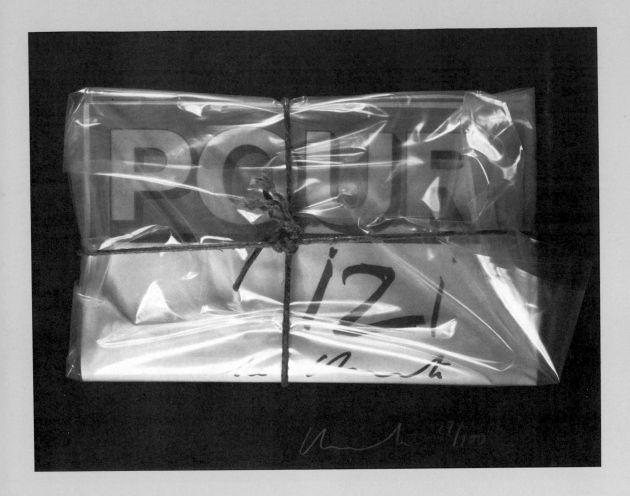

50. Verpackte Zeitschrift „Pour"

1977
Zeitschrift „Pour" gefaltet und mit Bindfaden in
transparente Folie verpackt
Maße: 29,5 x 35 x 5 cm
Auflage: 100 von Christo handgemachte Exemplare
Herausgeber: Isi Fiszman, Brüssel (Zeitschrift „Pour")

Herausgegeben zur finanziellen Unterstützung der radikalen
belgischen Zeitschrift „Pour", zusammen mit Arbeiten zahlreicher
anderer Künstler.

50. Journal "Pour", Wrapped

1977
The newspaper "Pour" folded and wrapped with
transparent polyethylene and rope
Size: 29.5 x 35 x 5 cm
Edition: 100 copies, handmade by Christo
Publisher: Isi Fiszman, Brussels (Journal „Pour")

The radical Belgien Journal "Pour", was in one of its frequent
financial crises, when Harald Szeemann initiated a sale of works
donated by several artists, for the benefit of the journal. The
sale was organized through an exhibition which took place in a
tent, where several artists also gave performances. When
people bought tickets for the performances, they won original
works by the participating artists.

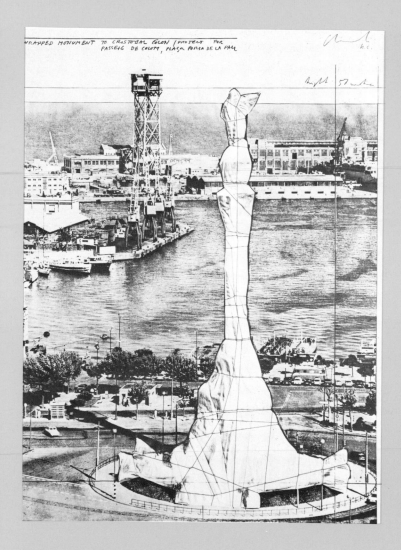

WRAPPED MONUMENT TO CRISTOBAL COLON (PROJECT FOR PASSEIG DE COLOM, PLAÇA PORTA DE LA PAU)

51. Verpacktes Denkmal für Cristobal Colòn, Projekt für Barcelona

1977
Farblithographie, 75,5 x 55,4 cm
Auflage: 75 Exemplare (+ 10 A. P. + 10 H. C.)
Papier: Guarro
Photograph: Wolfgang Volz
Drucker: La Poligrafa, Barcelona
Herausgeber: Ediciones Poligrafa, Barcelona

Da das Denkmal im Gelände der Schiffswerft von Barcelona, nicht weit vom Regierungs- und Polizeigebäude liegt, befürchteten die Behörden Krawalle und Demonstrationen und versagten deshalb die Genehmigung zum Verpacken.

51. Wrapped Monument to Cristobal Colòn, Project for Barcelona

1977
Color lithograph, 75.5 x 55.4 cm
Edition: 75 copies, 10 artist's proofs and 10 Hors Commerce
Paper: Guarro
Photographer: Wolfgang Volz
Printer: La Poligrafa, Barcelona
Publisher: Ediciones Poligrafa, Barcelona

Since the monument is situated in the shipyard of Barcelona, not far from the Government and Police Headquarters, the authorities feared turmoil and demonstrations and did not give permits for the wrapping.

52. Rotes Schaufenster, Projekt

1977
Farbsiebdruck, collagiert mit braunem Packpapier
Maße: 71 x 56 cm
Auflage: 120 Exemplare (+ 20 A. P.)
Papier: Karton, weiß
Drucker: Hans-Peter Haas, Stuttgart
Herausgeber: Verlag Gerd Hatje, Stuttgart und
Edition Schellmann & Klüser, München

Herausgegeben zur Finanzierung des Buches „The Running
Fence Project – Christo", siehe Nr. 49
Thematisch: vgl. Nr. 5, 6, 59, 60

52. Red Store Front, Project

1977
Color screenprint, collaged with brown wrapping paper
Size: 71 x 56 cm
Edition: 120 copies and 20 artist's proofs
Paper: Cardboard
Printer: Hans-Peter Haas, Stuttgart
Publisher: Verlag Gerd Hatje, Stuttgart and
Edition Schellmann & Klüser, Munich

Made to help fund the publication of the book "The Running
Fence Project – Christo", see No. 49
Subject relates to Nos. 5, 6, 59, 60

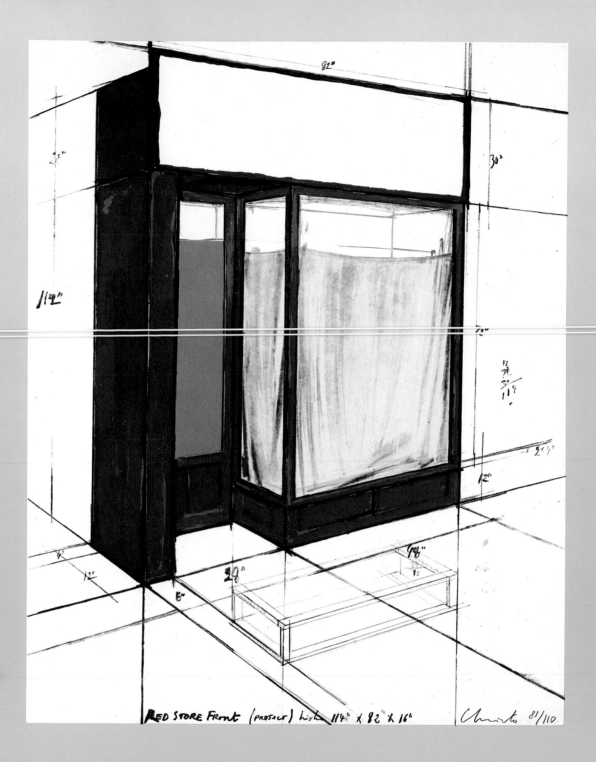

RED STORE FRONT (PROJECT) high. 114" × 82" × 16" Christo 81/110

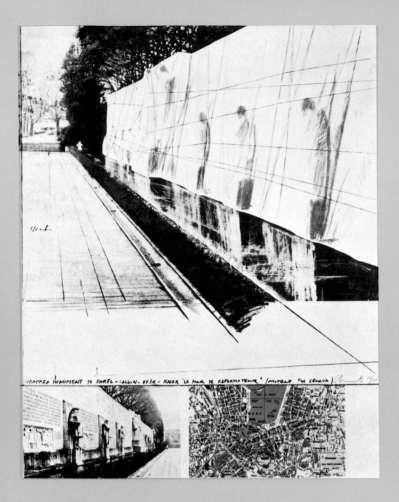

53. Verpackte „Reformatoren-Mauer", Projekt für Genf

1977
Farblithographie und Collage (Stoff, Bindfaden, Photo
und Stadtplan)
Maße: 71,5 x 56 cm
Auflage: 100 Exemplare (+ 10 A. P.)
Papier: Rives Bütten, auf Karton aufgezogen
Drucker: Matthieu, Zürich
Photograph: Wolfgang Volz
Herausgeber: Graphik International, Stuttgart

Das Projekt war Teil des Planes, drei Sehenswürdigkeiten von
Genf zu verpacken: Die Reformatoren-Mauer, die Fontäne im
Genfer See und die Statue von General Dufour, dem Gründer
des Kantons Genf, vor dem Rath Museum.
Nach Wien hatte Christo im Winter 1957/58 acht Monate lang
in Genf gelebt, bevor er nach Paris ging.

53. Wrapped "Mur des Reformateurs", Project for Geneva

1977
Color lithograph collaged with fabric, twine, photograph and plan
Size: 71.5 x 56 cm
Edition: 100 copies and 10 artist's proofs
Paper: Rives, mounted on cardboard
Printer: Matthieu, Zürich
Photographer: Wolfgang Volz
Publisher: Graphik International, Stuttgart

The project was planned as one of three wrappings of Geneva
landmarks: The Wall, the "Jet d'Eau" in the Lac Leman and the
statue of General Dufour, founder of the Canton of Geneva,
located in front of the Rath Museum.
After he had left Vienna in 1957, Christo lived in Geneva in the
winter of 1957/58 and went on to Paris in 1958.

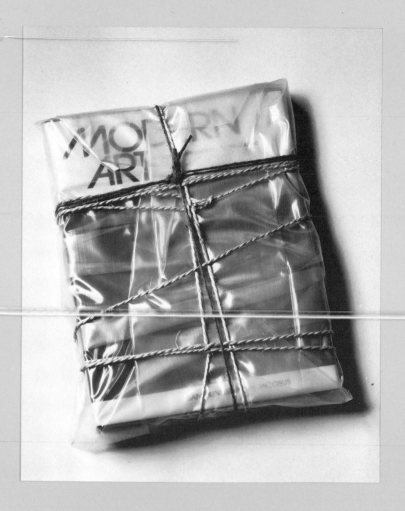

54. Verpacktes Buch „Moderne Kunst"

1978
Buch „Moderne Kunst", (von Sam Hunter und John Jacobus),
mit Bindfaden in transparente Folie verpackt
Maße: 34,5 x 25,5 x 4,5 cm
Auflage: 120 Exemplare (+ 20 A. P.)
Herausgeber: Abrams Original Editions, New York

Die Auflage wurde gemacht, um die Finanzierung des Buches
„Christo – Running Fence", erschienen bei Abrams, zu
unterstützen.

54. Wrapped Modern Art Book

1978
The Book "Modern Art", (by Sam Hunter and John Jacobus),
wrapped in polyethylene and twine
Size: 34.5 x 25.5 x 4.5 cm
Edition: 120 copies and 20 artist's proofs
Publisher: Abrams Original Editions, New York

Made to help fund the publication of the book "Christo – Running
Fence", photographs by Gianfranco Gorgoni, narrative text by
David Bourdon, chronicle by Calvin Tomkins.

55. Running Fence,
Sonoma und Marin Counties, Kalifornien

1979
Fünf Farbdrucke (Dye-transfer)
Maße: 50 x 60 cm
Auflage: 50 Exemplare, signiert von Christo und Wolfgang Volz
Photograph: Wolfgang Volz
Herausgeber: Galerie Habermann, Göttingen
und Wolfgang Volz

Christo signierte die Edition, um seinem Freund und Photographen Wolfgang Volz zu danken.

„Running Fence wurde am 10. September 1976 fertiggestellt. Er war 5,50 m hoch, 40 km lang und verlief nördlich von San Francisco, in Ost-West-Richtung, auf den Grundstücken von 59 Ranchern, er durchquerte die hügelige Landschaft und endete im Pazifischen Ozean in der Bodega Bucht.
Das „Gesamtkunstwerk" bestand aus: 42 Monaten Arbeit aller Beteiligten, der Mitwirkung der Rancher, 18 öffentlichen Hearings, 3 Verhandlungen am Obersten Gerichtshof in Kalifornien, der Abfassung eines 45-seitigen Berichts über die Auswirkungen des Projekts auf die Umwelt und der zeitweiligen Benutzung der Hügel, des Himmels und des Meeres.
Der „laufende Zaun" wurde von Christo geplant und selbst finanziert. Er bestand aus 150 000 m weißen Nylongewebes, aufgehängt an einem Stahlseil, das über 2050 Stahlpfosten (6 m lang, 8,5 cm ∅) gespannt war. Die Pfosten waren 90 cm im Boden versenkt und wurden, ohne Betonfundamente, seitlich mit Halteseilen im Boden verankert, wobei insgesamt 144 km Stahlseil und 14 000 Erdhaken verbraucht wurden. Die oberen und unteren Enden der 2050 Stoffbahnen wurden mit 350 000 Haken an oben und unten verlaufenden Stahlseilen befestigt. Die ganze Konstruktion war so ausgelegt, daß sie vollständig wieder abgebaut werden konnte.
Da Running Fence 14 Straßen überquerte und durch die Stadt Valley Ford führte, mußten an vielen Stellen Durchgänge für Autos, Vieh und Wild geschaffen werden. Der Zaun war so angelegt, daß man seinem Verlauf auf den Landstraßen der Counties Sonoma und Marin im Auto folgen konnte.
14 Tage nach der Fertigstellung des Running Fence wurde dessen Abbau begonnen und alles Material den Ranchern geschenkt."
(Aus der Pressemitteilung des Projekts, 1976)

55. Running Fence,
Sonoma and Marin Counties, California

1979
Five colorprints (dye-transfer)
Size: 50 x 60 cm
Edition: 50 copies, signed by Christo and Wolfgang Volz
Photographer: Wolfgang Volz
Publisher: Galerie Habermann, Göttingen
and Wolfgang Volz

Christo signed the edition to thank his friend and photographer Wolfgang Volz.

"Running Fence, 18. ft. high, 24.½ miles long, extending East-West near Freeway 101, north of San Francisco, on the private property of 59 ranchers, following the rolling hills and dropping down to the Pacific Ocean at Bodega Bay, was completed on September 10th, 1976.
The art project consisted of: 42 months of collaborative efforts, the ranchers' participation, 18 Public Hearings, 3 sessions at the Super Courts of California, the drafting of a 450 page Environmental Impact Report and the temporary use of the hills, the sky and the ocean.
Conceived and financed by Christo, "Running Fence" was made of 165,000 yards of heavy woven white nylon fabric, hung from a steel cable strung between 2,050 steel poles (each: 21 ft. long, 3½ inch diameter) embedded 3 ft. into the ground, using no concrete and braced laterally with guy wires (90 miles of steel cable) and 14,000 earth anchors. The top and bottom edges of the 2,050 fabric panels were secured to the upper and lower cables by 350,000 hooks. All parts of Running Fence's structure were designed for complete removal. Running Fence crossed 14 roads and the town of Valley Ford, leaving passage for cars, cattle and wildlife and was designed to be viewed by following 40 miles of public roads, in Sonoma and Marin Counties".
The removal of Running Fence started 14 days after its completion and all materials were given to the Ranchers."
(From Press Release for project, 1976)

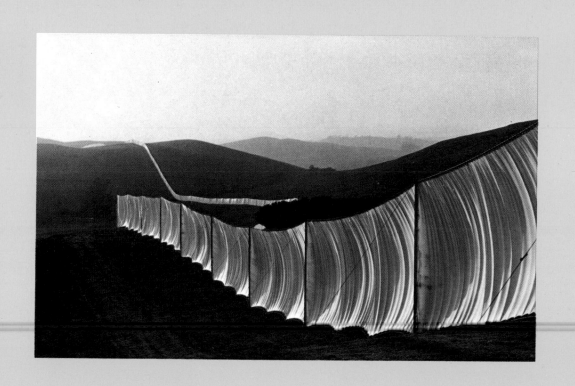

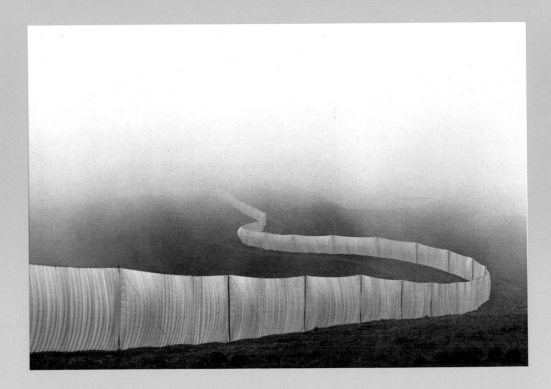

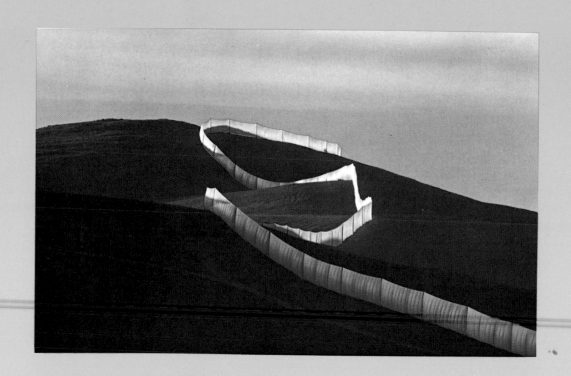

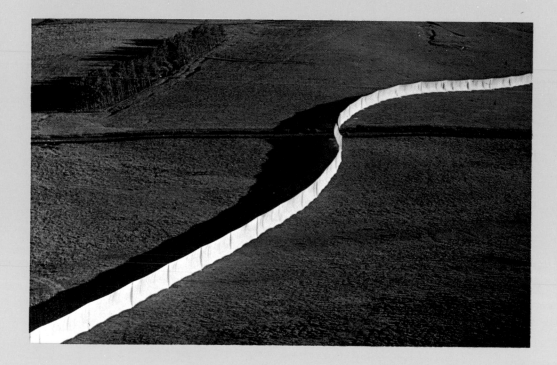

56. Verpackter Baum, Projekt

1979
Farblithographie und Collage (Plastikfolie,
Stoff und Bindfaden)
Maße: 56 x 71 cm
Auflage: 99 Exemplare (+ 15 A. P. + 15 H. C.)
Papier: Brauner Karton
Drucker: La Poligrafa, Barcelona
Herausgeber: Ediciones Poligrafa, Barcelona

Herausgegeben zur Finanzierung des Running Fence Projekts.
Vgl. Nr. 23

56. Wrapped Tree, Project

1979
Color lithograph on cardboard, collaged with
polyethylene, fabric and twine
Size: 56 x 71 cm
Edition: 99 copies, 15 artist's proofs and 15 Hors Commerce
Paper: Brown cardboard
Printer: La Poligrafa, Barcelona
Publisher: Ediciones Poligrafa, Barcelona

Made to help finance the "Running Fence" project.
See also No. 23

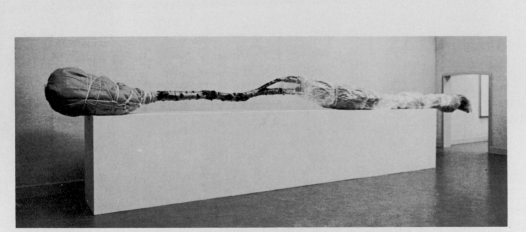

Packed Tree, 1966
Stedelijk van Abbemuseum, Eindhoven

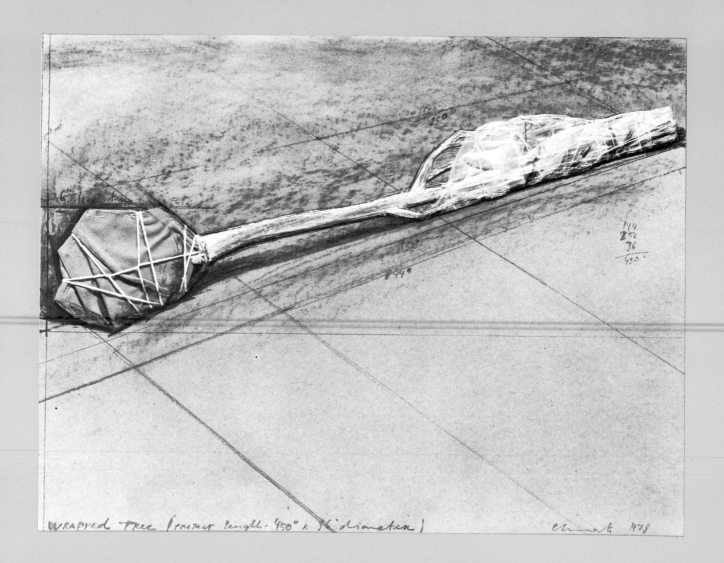

WRAPPED TREE (project length 450" x 36" diameter) Christo 1978

57. Verpacktes „Chicago Magazine"

1980
Mehrere Exemplare der Zeitschrift „Chicago",
zusammengepackt mit Plastikfolie und Bindfaden
Maße: 28 x 22 x 2 cm
Auflage: 35 von Christo handgemachte Exemplare (+ 5 A. P.)
Herausgeber: Museum of Contemporary Art, Chicago

Die Edition ist ein Geschenk an das Museum, das Christo 1969
eingepackt hatte (s. Nr. 29)

57. "Chicago Magazine" Wrapped

1980
Several news magazines "Chicago" wrapped together
with polyethylene and rope
Size: 28 x 22 x 2 cm
Edition: 35 copies and 5 artist's proofs, handmade by Christo
Publisher: Museum of Contemporary Art, Chicago

Made as a present to the Museum of Contemporary Art, Chicago,
which Christo had wrapped in 1969, (see No. 29)

58. Oranges Schaufenster, Projekt

1980
Farblithographie, collagiert mit braunem Papier
Maße: 37,5 x 27,5 cm
Auflage: 100 Exemplare (+ 18 A. P.)
Papier: Guarro
Drucker: La Poligrafa, Barcelona
Herausgeber: Ediciones Poligrafa, Barcelona

Erschienen in der Mappe „15 Jahre Poligrafa" zusammen mit
Blättern von 18 anderen Künstlern.

58. Orange Store Front, Project

1980
Color lithograph with collaged brown paper
Size: 37.5 x 27.5 cm
Edition: 100 copies and 18 artist's proofs
Paper: Guarro
Printer: La Poligrafa, Barcelona
Publisher: Ediciones Poligrafa, Barcelona

Included in the portfolio "15 years of Poligrafa" with works
by 19 artists.

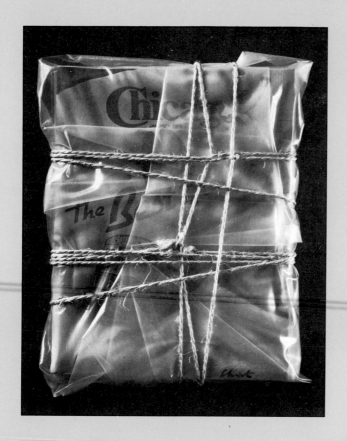

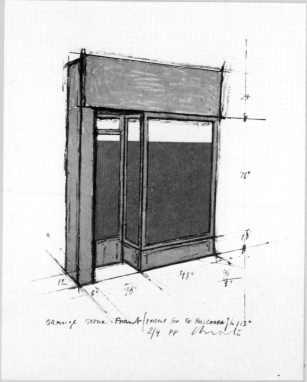

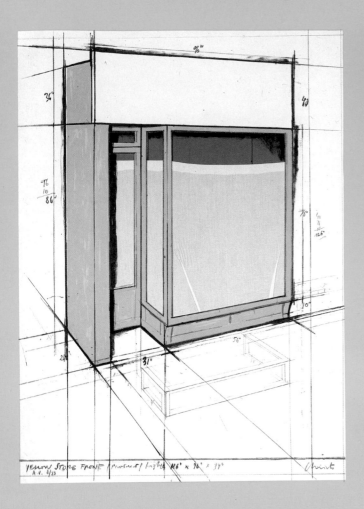

59. Gelbes Schaufenster, Projekt

1980
Farblithographie und Collage (Plexiglas und Stoff)
Maße: 81,2 x 59,5 cm
Auflage: 100 Exemplare (+ 23 A. P.)
Papier: Arches Bütten, auf Karton aufgezogen
Drucker: Landfall Press, Chicago
Herausgeber: Abrams Original Editions, New York

Die Edition war ein Geschenk Christo's an den Harry N. Abrams
Verlag, zur Finanzierung des Buches „Wrapped Walk Ways".

59. Yellow Store Front, Project

1980
Color lithograph and collage of acetate and cloth
Size: 81.2 x 59.5 cm
Edition: 100 copies and 23 artist's proofs
Paper: Arches, mounted on cardboard
Printer: Landfall Press, Chicago
Publisher: Abrams Original Editions, New York

This edition was a present from Christo to Harry N. Abrams
Publications to help in the publication of the book "Wrapped
Walk Ways".

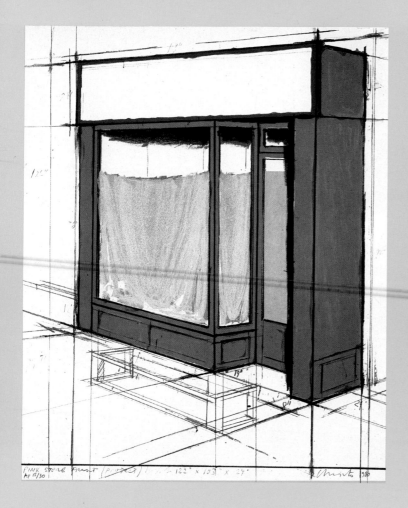

60. Rosa Schaufenster, Projekt

1980
Farblithographie, collagiert mit braunem Papier
Maße: 56,5 x 45,7 cm
Auflage: 100 Exemplare (+ 30 A. P. + 10 S. P.)
Papier: Arches Bütten, auf Karton aufgezogen
Drucker: Landfall Press, Chicago
Herausgeber: Makoto Ohaka, Yoshiaki Tono,
Yoich Yamamoto und Nantenshi Gallery, Tokio

Die Edition war ein Geschenk Christo's an die Familie Shimizu,
Begründer der Minami Galerie in Tokio, in der Christo 1977
ausgestellt hatte. Das Blatt erschien in der Mappe „Marginalien"
mit dem Untertitel „Hommage to Shimizu" zusammen mit
Graphiken von Tinguely, Francis, Johns und Oldenburg

60. Pink Store Front, Project

1980
Color lithograph, with collaged brown paper
Size: 56.5 x 45.7 cm
Edition: 100 copies, 30 artist's proofs and 10 subscriber's proofs
Paper: Arches, mounted on cardboard
Printer: Landfall Press, Chicago
Publisher: Mr. Makoto Ohaka, Mr. Yoshiaki Tono,
Mr. Yoich Yamamoto and Nantenshi Gallery, Tokyo

The edition was a present from Christo to the family of Mr.
Shimizu, founder of the Minami Galery, Tokyo, where Christo
had an exhibition in 1977. The print is part of a portfolio also
containing works by: Tinguely, Francis, Johns and Oldenburg.
The portfolio is titled "Marginalia" with "Homage to Shimizu" as
subtitle, and contains a preface by Mr. Makoto Ohaka and a text
by Mr. Yoshiaki Tono.

61. Zwei verpackte Hochhäuser von Manhatten, Projekt

1980
Farblithographie und Collage (Stoff, Bindfaden und Stadtplan)
Maße: 70,8 x 55,5 cm
Auflage: 99 Exemplare (+ 15 A. P. + 15 H. C.)
Papier: Weißer Karton, auf stärkeren Karton aufgezogen
Photograph: Raymond de Seynes
Drucker: La Poligrafa, Barcelona
Herausgeber: Ediciones Poligrafa, Barcelona

Christo's voller Terminkalender führte zu einer 6-jährigen Verzögerung der Fertigstellung dieser Edition, die 1974 vereinbart worden war, als Christo Geld für das Running Fence Projekt brauchte.

61. Two Lower Manhattan Buildings Wrapped, Project

1980
Color lithograph and collage (fabric, twine and plan)
Size: 70.8 x 55.5 cm
Edition: 99 copies and 15 artist's proofs and 15 H. C.
Paper: White board, mounted on cardboard
Photographer: Raymond de Seynes
Printer: La Poligrafa, Barcelona
Publisher: Ediciones Poligrafa, Barcelona

Christo's tight work schedule caused a delay of 6 years in the completion of this edition which Poligrafa had planned to publish in 1974 when Christo needed funds for the "Running Fence" project.

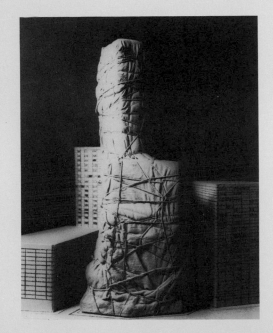

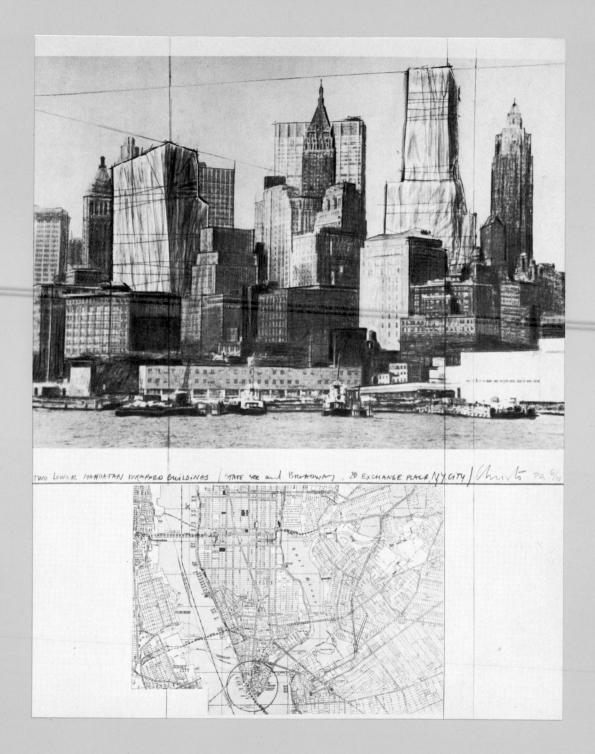

TWO LOWER MANHATAN WRAPPED BUILDINGS (STATE SOR and BROADWAY, 20 EXCHANGE PLACE N.Y.CITY) Christo PA 6/10

62. Verpackte Puerta de Alcalà, Projekt

1981
Farblithographie und Collage (Stoff, Bindfaden,
Stadtplan und Photo)
Maße: 70,5 x 55 cm
Auflage: 99 Exemplare (+ 15 A. P. + 15 H. C.)
Papier: Weißer Karton, auf stärkeren Karton aufgezogen
Drucker: La Poligrafa, Barcelona
Herausgeber: Ediciones Poligrafa, Barcelona

1975 wollte Christo ein Monument in Spanien verpacken. Zur
Auswahl standen: die Puerta de Alcalà in Madrid, das Monument
für Cristobal Colòn und die Fontana de Jujol auf der Plaza de
Espagna, beide in Barcelona. Christo entschloß sich, die Geneh-
migungen zum Verpacken des Monuments für Cristobal Colòn
zu beantragen; das Projekt ist bis heute nicht abgeschlossen.
(s. Nr. 51)

62. Puerta De Alcalà, Wrapped, Project for Madrid

1981
Color lithograph, collaged with fabric, twine, map
and photograph
Size: 70.5 x 55 cm
Edition: 99 copies, 15 artist's proofs and 15 Hors Commerce
Paper: White board, mounted on cardboard
Printer: La Poligrafa, Barcelona
Publisher: Ediciones Poligrafa, Barcelona

In 1975 Christo was considering doing a project in Spain. The
possibilities were: the Puerta de Alcalà in Madrid, the Monument
to Cristobal Colòn and La Fontana de Jujol at Plaza de Espagna;
both in Barcelona. Christo chose to try to obtain permission to
wrap the Monument to Cristobal Colòn and the project is still in
progress. (see No. 51)

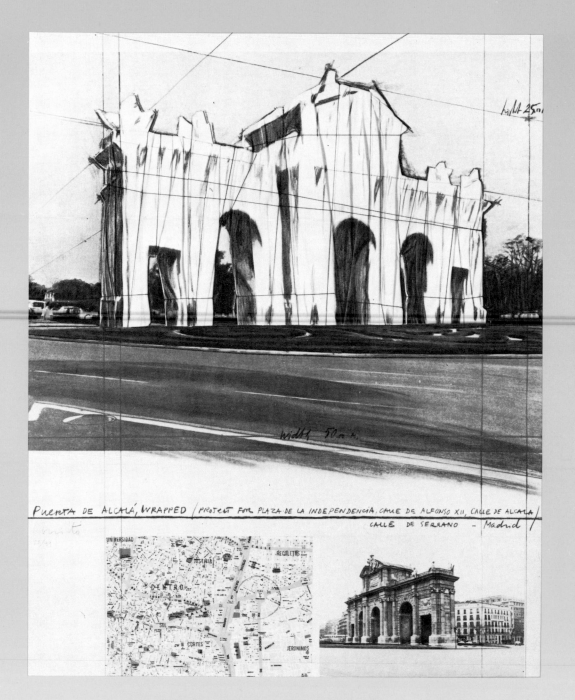

Puerta de Alcalá, Wrapped /Project for Plaza de la Independencia, Calle de Alfonso XII, Calle de Alcalá/ Calle de Serrano - Madrid/

63. Paket auf Sackkarre, Projekt

1981
Farblithographie und Collage (braunes Leinen,
Bindfaden und Heftklammern)
Maße: 71 x 56,5 cm
Auflage: 100 Exemplare (+ 20 A. P. + XX S. P.)
Papier: Weißer Karton, auf stärkeren Karton aufgezogen
Drucker: Landfall Press, Chicago
Herausgeber: Abrams Original Editions, New York

Christo machte verschiedene Objekte auf Rädern, z. B.: „Paket
auf Schubkarre", „Verpacktes Motorrad", „Verpackter Volkswa-
gen" (zerstört), „Verpackter Wagen", „Verpackter Volvo".

63. Package on Handtruck, Project

1981
Color lithograph, collaged with brown canvas, twine and staples
Size: 71 x 56.5 cm
Edition: 100 copies, 20 artist's proofs and
XX subscriber's proofs
Paper: White Museum Board, mounted on cardboard
Printer: Landfall Press, Chicago
Publisher: Abrams Original Editions, New York

Christo did several wrapped objects on wheels, such as "Package
on Wheelbarrow", "Wrapped Motorcycle", "Wrapped Volkswagen"
(no longer in existence), "Wrapped Carozza", "Wrapped Volvo".

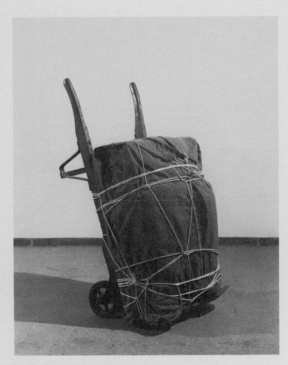

Package on Hand Truck, 1973
Collection of Whitney Museum of American Art, New York

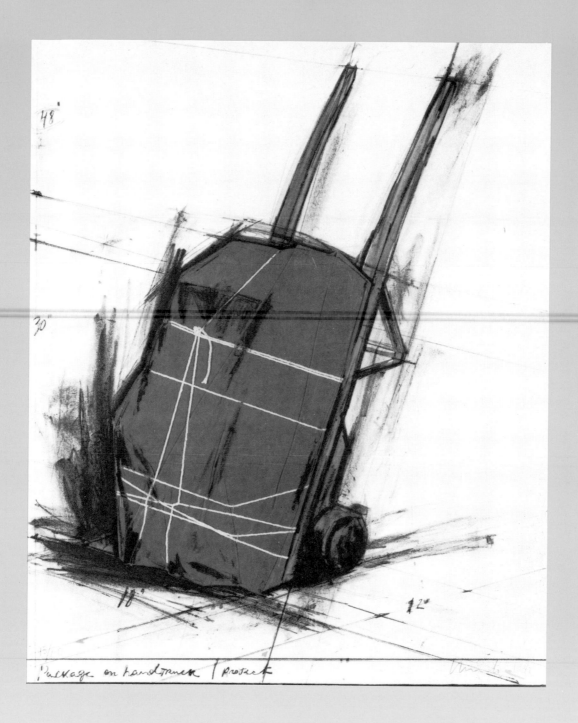

48"

30"

18" 12"

Package on handtruck / Project

64. Running Fence

1982
Farbsiebdruck, 56 x 76 cm
Auflage: 300 Exemplare (+ 30 A. P.),
signiert von Christo und Wolfgang Volz
Photograph: Wolfgang Volz
Drucker: Hans-Peter Haas, Stuttgart
Herausgeber: Presseamt der Landeshauptstadt Kiel

Das Blatt wurde anläßlich der Jubiläumsveranstaltung „100 Jahre
Kieler Woche" zusammen mit Blättern von Antes, Hausner und
Wunderlich herausgegeben.

Projekt: siehe Nr. 55

64. Running Fence

1982
Color screenprint, 56 x 76 cm
Edition: 300 copies and 30 artist's proofs,
signed by Christo and Wolfgang Volz
Photographer: Wolfgang Volz
Printer: Hans-Peter Haas, Stuttgart
Publisher: City of Kiel, Germany

The print was published on the occasion of the celebration of
the 100th anniversary of "Kiel Week", a sailing and regatta
festival on the East-Sea. It came in a portfolio together with
prints by Antes, Hausner and Wunderlich.

Project: see No. 55

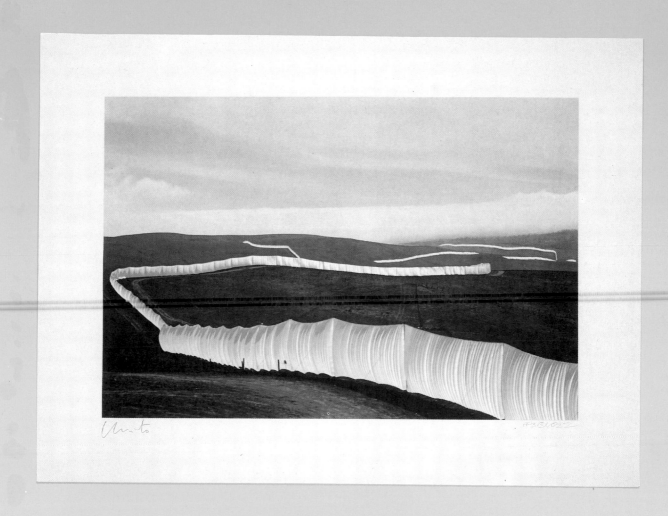

Christo F3 Christo

65. Verpackter Fußboden – Haus Lange Krefeld

1982
Farblithographie, collagiert mit braunem
Packpapier und bemaltem Stoff
Maße: 71 x 56 cm
Auflage: 100 Exemplare
(+ 20 A. P. + XXV römisch numerische Exemplare)
Papier: Arches Bütten, auf Karton aufgezogen
Drucker: Landfall Press, Chicago
Herausgeber: Edition Schellmann & Klüser, München

Die Ausstellung „Verpackter Fußboden, verpackte Gehwege"
fand vom 1. Mai bis 27. Juni 1971 im Haus Lange des Kaiser-Wil-
helm-Museums Krefeld statt. Das Ungewöhnliche des Gebäudes
von Mies van der Rohe besteht in der Verbindung von Innerem
und Äußerem. In dem Projekt trennte Christo Innen und Außen,
indem er die Fenster mit braunem Packpapier abdeckte. Im
Inneren des Gebäudes verpackte er die Fußböden des Erdge-
schosses, außen bedeckte er den 100 Meter langen Weg mit
einer unscheinbaren grau-beigen Kunststoff-Plane.

65. Wrapped Floor – Haus Lange Krefeld

1982
Color lithograph, collaged with brown
wrapping paper and handpainted cloth
Size: 71 x 56 cm
Edition: 100 copies and 20 artist's proofs
and XXV Roman numerals
Paper: Arches cover white, mounted on board
Printer: Landfall Press, Chicago
Publisher: Edition Schellmann & Klüser, Munich

The exhibition "Wrapped Floors, Wrapped Walk Ways", was
installed from May 1 to June 27, 1971 at Haus Lange, part of
the Kaiser Wilhelm Museum, Krefeld, West Germany. The genius
of this house, designed by Mies van der Rohe in 1928 for Ulrich
Lange, is through the integration of in and outdoors. In the
project, Christo separated the inside from the outside by blocking
the windows with a brown paper covering. Inside the two-story
house, he covered the floors of the ground story. Outside, he
covered the 100-meter walk with a taupe-colored synthetic
fabric, of extremely inelegant character.

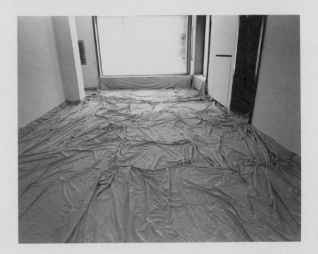